D0596936

PARIS
architecture & design

Edited and written by Christian van Uffelen
Concept by Martin Nicholas Kunz

teNeues

introduction 6

to see . living

01 Îlot Candie Saint-Bernard 14
02 Maison de Retraite 16
03 Rue des Suisses 18
04 Résidence Universitaire Croisset 20
05 Tour Totem 22
06 Rue Pelleport 24

to see . office

07 Place du Marché-Saint-Honoré 26
08 Cœur Défense 28
09 Exaltis Tower 30
10 La Grande Arche 32
11 Tour EDF – Electricité de France 34
12 Tour Pacific et Pont Japon 36
13 Tour t1 38

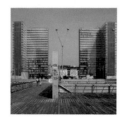

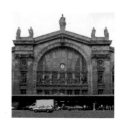

to see . culture & education

14 Le Grand Louvre 40
15 Pavillon de l'Arsenal 44
16 Centre Georges-Pompidou 46
17 Institut du Monde Arabe 50
18 Musée du Quai Branly 52
19 UNESCO 54
20 Bibliothèque nationale de France
 Site François Mitterrand 56
21 Fondation Cartier
 pour l'Art Contemporain 58
22 Musée national
 des Arts asiatiques-Guimet 60
23 Palais de Tokyo 62
24 Cité de la Musique 64
25 Cité des Sciences et de l'Industrie 66
26 Fondation d'art contemporain
 François Pinault 68

to see . public

27 Passerelle Solférino 70
28 Mur pour la Paix 72
29 Gare du Nord 74
30 Notre-Dame-d'Espérance 76
31 Parc de Bercy 78
32 Passerelle Bercy-Tolbiac 80
33 Promenade plantée 82
34 Notre-Dame de l'Arche d'Alliance 84
35 Le Jardin Atlantique 86
36 Parc André-Citroën 88
37 Parc de la Villette 90
38 Saint-Luc 92
 Rénovation du Mètro et Ligne Météor
39 Lentille Météor St.-Lazare 94
40 Bibliothèque nationale de France 96
41 Kiosque de Noctambules 97
42 Aéroport
 Charles de Gaulle Roissy-2 98
43 Notre-Dame-de-la-Pentecôte 100
44 Cathédrale de la Résurrection 102

to stay . hotels

45 Artus Hôtel 106
46 Bel-Ami 110
47 Hôtel de la Trémoille 112
48 Pershing Hall 114
49 Hôtel Costes K 116

to go . eating, drinking, clubbing

50 Étienne Marcel 120
51 Andy Wahloo 122
52 Georges 124
53 Joe's Café à Joseph 128
54 La Cantine du Faubourg 130
55 La Maison Blanche 132
56 La Suite 134
57 Lô Sushi 136
58 Les Grandes Marches 138
59 Café Nescafé 140

to go . wellness, beauty & sport

to shop . mall, retail, showrooms

60	Shiseido la Beauté	142
61	UGC Cine Cité	144
62	MK2 Bibliothèque	146
63	Stade de France	148

64	Colette	152
65	Comme des Garçons Parfums	154
66	Giorgio Armani	156
67	Immeuble Pont-Neuf Kenzo	158
68	Mandarina Duck	160
69	Librairie Florence Loewy	162
70	Pleats Please Issey Miyake	164
71	Boutique Momi	166
72	Comme des Garçons Red-Boutique	168
73	Espace d'exposition Citroën	170
74	Fendi	172
75	L'Atelier Renault	174
76	Centre Commercial Bercy Village	176
77	Le Viaduc des Arts	178
78	Sephora Bercy	180

index

Architects / Designers / Districts	182
Photo Credits / Imprint	188
Map / Legend	190

introduction

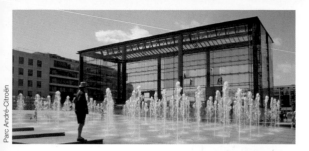

Parc André-Citroën

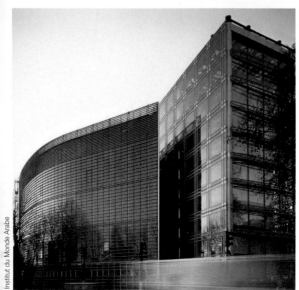

Institut du Monde Arabe

The construction projects of monarchs and in recent times presidents, who thus eternalized themselves independent of city and state have always been formative for Paris. Charles de Gaulle provided the "New Cities" that surround Paris in a "great corona", Georges Pompidou left behind the Centre now named after him, Giscard d'Estaing initiated the Parc und Cité des Sciences in La Villette, but François Mitterrand outdid them all: the Louvre reconstruction, the new opera, the Institut du Monde Arabe, the Grande Arche, the Cité de la Musique and the Bibliothéque Nationale are all attributable to him. Since then, the main focus of construction measures lies in less conspicuous projects and extensive restructuring procedures (Zones d'Aménagement Concertées, ZAC). The *architecture & design guide* at hand concentrates on these and on the most important and more recent "large government projects". Along with about 40 buildings, numerous appealingly designed hotels, restaurants, and showrooms, the "savoir vivre" of the French metropolis is aimed at further increasing appreciation.

Prägend für Paris waren immer die Bauprojekte der Regenten, in neuerer Zeit der Präsidenten, die sich damit unabhängig von Stadt und Staat verewigten. Charles de Gaulle sorgte für die „Neuen Städte", die Paris in einer „Großen Korona" umschließen, Georges Pompidou hinterließ das heute nach ihm benannte Centre, Giscard d'Estaing initiierte Parc und Cité des Sciences in La Villette, aber François Mitterrand übertraf sie alle: Der Louvre-Umbau, die neue Oper, das Institut du Monde Arabe, die Grande Arche, die Cité de la Musique und die Bibliothéque Nationale gehen auf ihn zurück. Seitdem liegt der Schwerpunkt des Baugeschehens auf weniger auffälligen Projekten und auf großflächigen Restrukturierungsmaßnahmen (Zones d'Aménagement Concertées, ZAC). Auf diese und die wichtigsten der jüngeren „Großen Staatsprojekte" konzentriert sich der vorliegende architecture & design guide. Neben rund 40 Hochbauten sollen zahlreiche ansprechend gestaltete Hotels, Restaurants und Showrooms das „savoir vivre" der französischen Metropole näher bringen.

Centre Georges-Pompidou

9

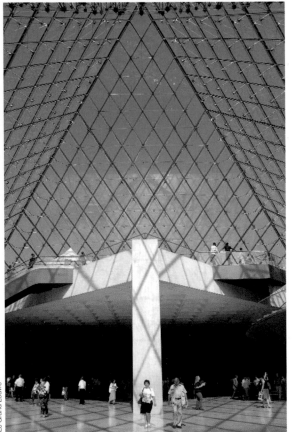

Le Grand Louvre

Paris a toujours été marqué par les projets de construction des régents et à une époque plus récente, des présidents qui se sont ainsi inscrits dans l'éternité, indépendamment de la ville et de l'état. Charles de Gaulle a lancé les « Villes nouvelles » qui entourent Paris dans une « grande ceinture », Georges Pompidou a laissé le Centre qui porte aujourd'hui son nom, Giscard d'Estaing a été l'initiateur du Parc et de la Cité des Sciences à La Villette, mais François Mitterrand les a tous dépassés : l'aménagement du Louvre, le nouvel Opéra, l'Institut du Monde Arabe, la Grande Arche, la Cité de la Musique et la Bibliothèque Nationale lui sont imputables. Depuis, le point principal du déroulement des chantiers est orienté sur des projets plus discrets et des mesures de restructuration de grande envergure (Zones d'Aménagement Concertées, ZAC). C'est sur ceux-ci et sur les plus importants des « grands projets d'état » que le présent guide de l'architecture et du design se concentre. Outre 40 grands immeubles, de nombreux hôtels, restaurants et showrooms aménagé de manière correspondante doivent initier au « savoir vivre » de la métropole française.

Para París siempre han sido determinantes los proyectos de construcción de los regentes, y en los últimos tiempos, los proyectos de los presidentes con los que se han perpetuado independientemente de la ciudad y el país. Charles de Gaulle se ocupó de las "Nuevas Ciudades" que rodeaban París en una "Gran Corona", George Pompidou dejó como legado el Centro que hoy lleva su nombre, Giscard d'Estaing inició el Parc y la Cité des Sciences en La Villette, pero François Mitterrand los superó a todos: la reconstrucción del Louvre, la nueva ópera, el Institut du Monde Arabe, el Grande Arche, la Cité de la Musique y la Bibliothéque Nationale le deben su origen. Desde entonces, el centro de las construcciones se sitúa sobre menos proyectos ostentosos y sobre medidas de reestructuración de grandes superficies (Zones d'Aménagement Concertées, ZAC). Esta guía de arquitectura y diseño se centra sobre dichas medidas y sobre los "proyectos estatales grandes" más importantes de los jóvenes. Alrededor de 40 edificios deben acercar a numerosos, restaurantes, salas de exposición y hoteles distribuidos de forma atractiva el "savoir vivre" de la metrópoli francesa.

Rue de la Paix & Place Vendôme

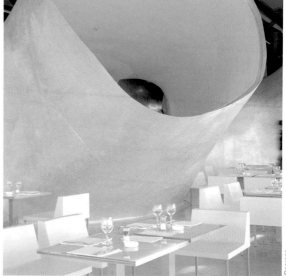

Georges

to see . living
office
culture & education
public

 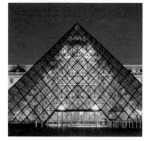 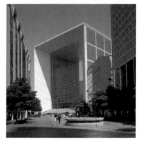

 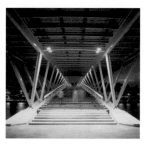 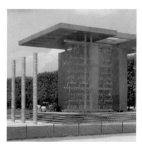

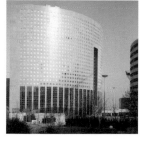 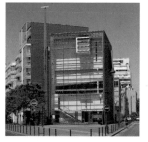 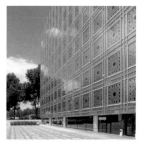

13

Logements sociaux, gymnase, bureaux
Îlot Candie Saint-Bernard
Council houses, gymnasium, offices

Massimiliano Fuksas

1996
Rue de Candie / pas. Saint-Bernard
11. Arrondissement

www.fuksas.it

The central motif of the renovated block of houses is a large wave of concrete that runs through the development. It stretches across the stores and flats as a roof and creates open spaces as well as the surface area of a largely underground sports hall. One can follow its course through the side streets.

Hauptmotiv des erneuerten Häuserblocks ist eine große Welle aus Beton, die durch die Bebauung läuft. Sie zieht sich als Dach über Geschäfte und Wohnungen hinweg und bildet Freiflächen sowie die Grundfläche einer großteils unterirdischen Sporthalle. In den Seitenstraßen kann man ihrem Verlauf folgen.

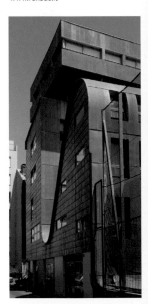

Le motif principal du bloc de maisons rénové est une grande vague en béton qui traverse la construction. Elle s'étend comme toit sur les magasins et les appartements et constitue des surfaces libres ainsi que la surface de base d'un gymnase en grande partie souterrain. Dans les rues latérales, on peut suivre son mouvement.

El motivo principal de los renovados bloques de viviendas es una gran onda de cemento que corre por la edificación. Se extiende como un techo sobre las tiendas y las viviendas y crea superficies libres y el área de una gran parte del polideportivo subterráneo. En las calles laterales puede seguirse su desarrollo.

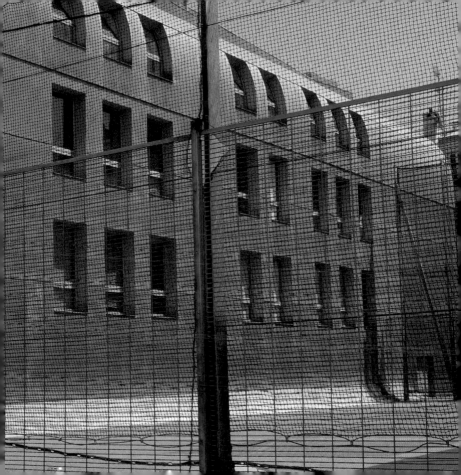

Maison de Retraite

Senior citizens' home

Architecture Studio

1998
28-30, rue Morand /
2-4 rue Desargues
11. Arrondissement

www.architecture-studio.fr

As a three winged construction, the home for senior citizens surrounds a garden toward which the entrance areas are turned: the short enclosed lift-and stairway area in the center sash and the completely glassed in passageways to the 90 apartments in the wings. Through their varying colors, the apartments can already be identified from the street.

La maison de retraite comprend comme installation en trois ailes un jardin sur lequel sont tournées les zones d'accès : Le court corps fermé de cage d'ascenseur et d'escalier de l'aile centrale et les couloirs complètement en verre et menant aux 90 appartement des ailes latérales. Grâce à leur coloration différente, les appartements sont déjà identifiables à partir de la rue.

Das Altenheim umfasst als dreiflüglige Anlage einen Garten, dem die Zugangsbereiche zugewandt liegen: Der kurze geschlossene Aufzugs- und Treppentrakt im Mittelflügel und die komplett verglasten Gänge zu den 90 Apartements in den Seitenflügeln. Durch ihre unterschiedliche Farbigkeit sind die Apartements schon von der Straße aus identifizierbar.

El asilo rodea con un edificio de tres alas un jardín, frente al que se sitúa la zona de acceso: el pequeño tramo cerrado del ascensor y las escaleras en el ala intermedia y los pasillos completamente acristalados conducen a los 90 apartamentos en las alas laterales. Los apartamentos pueden incluso distinguirse desde la calle gracias a los diferentes coloridos.

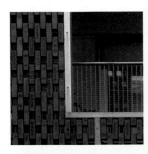

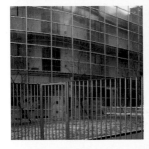

16

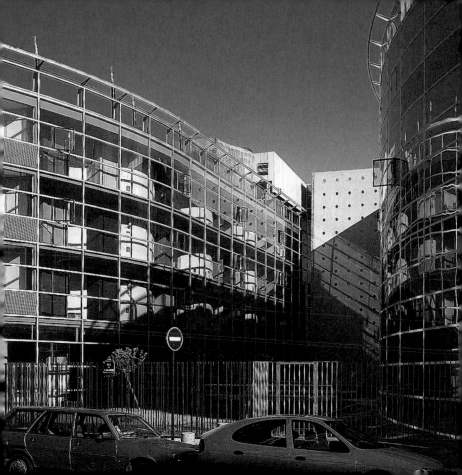

Logements sociaux
Rue des Suisses
Council houses

Herzog & de Meuron

2000
19, rue des Suisses /
4, rue Jonquoy
14. Arrondissement

Through surfaces made from unusual materials, the council flats exhibit a design typical of the Swiss office. Here, folding lattice work is set in front of the building that serve as shutters for the narrow balcony and develop the facade. Its format reminds one of the rectangular window openings in the surrounding buildings dating from the turn of the century.

Die Sozialwohnungen zeigen die für das Schweizer Büro typische Gestaltung der Oberflächen in ungewöhnlichen Materialien. Hier sind dem Gebäude aufklappbare Gitterelemente vorgesetzt, die als Fensterläden der schmalen Balkone dienen und die Fassade ausbilden. Ihr Format erinnert an die rechteckigen Fensteröffnungen der umliegenden Jahrhundertwendebebauung.

Les logements sociaux montrent l'aménagement des surfaces en matériaux insolites, typique du bureau suisse. Le bâtiment est muni d'éléments de grilles rabattables qui font office de persiennes pour les balcons étroits et constituent la façade. Leur format rappelle les ouvertures carrées des fenêtres des bâtiments environnants construits au tournant du siècle.

El diseño de las superficies de estas viviendas sociales, construidas en materiales muy poco comunes, refleja el estilo típico de este estudio suizo. La parte frontal de este edificio, está decorada con elementos reticulares, que sirven de postigos en los estrechos balcones y conforman la fachada. Su formato recuerda a las ventanas rectangulares de los edificios circundantes de fin de siglo.

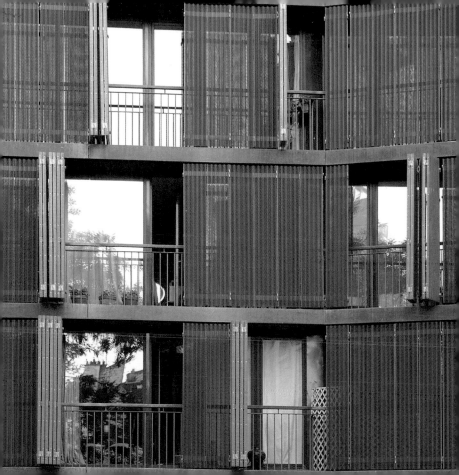

Résidence Universitaire Croisset

University residence hall Croisset

Architecture Studio

1996
4-8, rue Francis-de-Croisset
18. Arrondissement

www.architecture-studio.fr

The residential home consists of five elements: A cross-member that serves as a "noise barrier", a low administration wing behind it, and the three residential home sections. Like vaulted peaks, the residential sections tower above the administration, running crossways under it and pointing towards town.

Das Wohnheim besteht aus fünf Elementen: einem Riegel, der als „Lärmschutzwand" fungiert, einem niedrigen Verwaltungstrakt dahinter sowie den drei Wohnheimtrakten. Die Wohntrakte weisen oberhalb der quer zu ihnen verlaufenden Verwaltung in gewölbten Spitzen stadteinwärts.

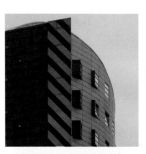

La résidence est composée de cinq éléments : d'une barre qui fait office de mur anti-bruit, un bâtiment administratif peu élevé situé derrière celle-ci ainsi que les trois bâtiments du foyer. Les bâtiments d'habitation font saillie comme pointe bombée au-dessus de l'administration s'étendant au-dessous d'eux et sont orientés en direction de la ville.

Esta residencia consta de cinco elementos: una construcción que desempeña la función de pared antirruido, detrás un tracto administrativo de baja altura y finalmente los tres tractos residenciales. Estos tractos residenciales con vistas hacia el centro de la ciudad sobresalen en forma de punta curvada por encima del tracto administrativo que discurre horizontalmente por debajo de ellos.

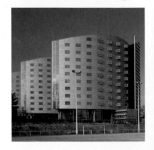

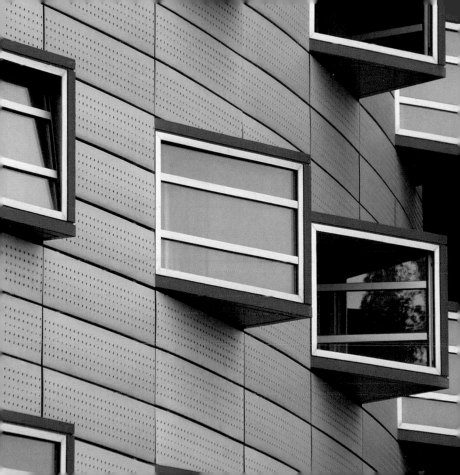

Logements
Tour Totem
Apartments

Tectône

1996
29, avenue de Flandre /
rue du Maroc
19. Arrondissement

www.tectone.net

Through division into three vertical segments, the apartment house has an even greater tower-like effect and can assert itself against the high 1960's constructions. The three segments are differentiated by their colors, which assimilate the colors in the surroundings. The inclination of the outer walls imparts the impression of a revolving group.

Grâce à la division en trois segments verticaux, l'effet de tour de l'immeuble d'habitation est renforcé et peut s'affirmer à côté des constructions élevées des années 1960. Les trois segments se distinguent dans les couleurs qui ont adopté celles de l'environnement. L'inclinaison des murs extérieurs laisse l'impression d'un groupe en rotation.

Durch die Aufteilung in drei vertikale Segmente wirkt das Apartmenthaus noch turmartiger und kann sich neben der hohen 1960er Jahre-Bebauung behaupten. Die drei Segmente unterscheiden sich in den Farben, die Umgebungsfarben aufnehmen. Die Neigungen der Außenwände lassen den Eindruck einer sich drehenden Gruppe entstehen.

Mediante la división en tres segmentos verticales, el edificio de apartamentos consigue una forma de torre y puede calificarse como una de las edificaciones más altas de los años 60. Los tres segmentos se diferencian entre sí por el color que adquieren los colores del entorno. Las inclinaciones de las paredes exteriores dan la impresión de un grupo girando.

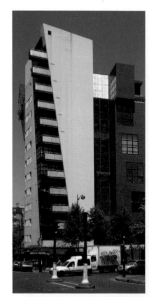

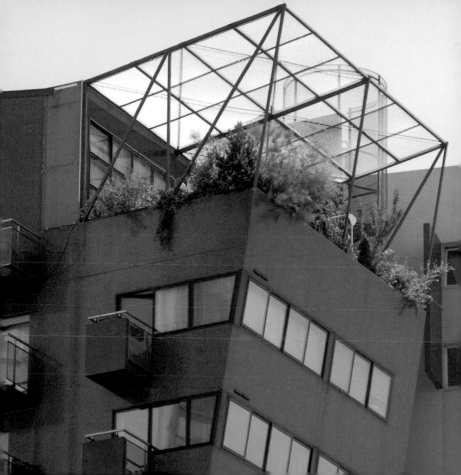

Logements
Rue Pelleport
Apartments

Frédéric Borel

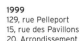

1999
129, rue Pelleport
15, rue des Pavillons
20. Arrondissement

Every side of this residential building offers an extremely different view. A calm, clearly arranged facade serves as the vanishing point of the Rue Pelleport, while the building flanks are meant to liven up the quarter through color and numerous breaks. The apartments, exhibit individual layouts through the inclinations and projections.

Jede Seite dieses Wohnhauses bietet eine sehr unterschiedliche Ansicht. Als Fluchtpunkt der Rue Pelleport dient eine ruhige übersichtliche Fassade, während die Hausflanken durch Farbe und zahlreiche Brüche das Viertel beleben sollen. Durch die Schrägen und Versprünge zeigen die Apartments individuelle Grundrisslösungen.

Chaque côté de cet immeuble d'habitation offre une vue très différente. C'est comme point de fuite de la Rue Pelleport que sert une façade calme et claire, alors que les pignons de la maison doivent répandre de la vie dans le quartier grâce à la couleur et à de nombreux brisis. Grâces aux pentes et aux sauts, les appartements montrent des solutions de planification individuelles.

Cada lado de este edificio de viviendas ofrece una perspectiva muy diferente. Una fachada tranquila y abierta sirve de punto de fuga de la Rue Pelleport, mientras que los flancos de la casa deben hacer que el barrio cobre vida gracias al color y a las numerosas fisuras. Cada uno de los apartamentos, muestra una solución particular de la planta gracias a las inclinadas y la ordenación.

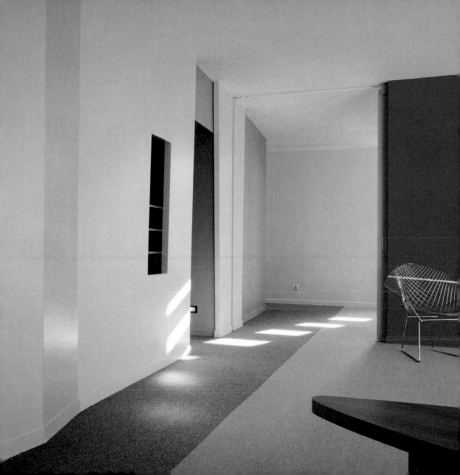

Bureaux et commerces
Place du Marché-Saint-Honoré
Offices and shops

Ricardo Bofill – Tallo de Arquitectura

1997
Place du Marché-Saint-Honoré
1. Arrondissement

www.bofill.com

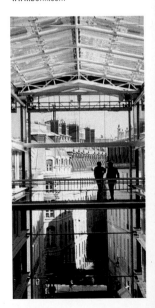

In the superstructure of Place du Marché-Saint-Honoré, Bofill connected two generously sized glazed building rows with a gable-ended roof in such a way that a passage has arisen in their midst. With its stores and offices, tympanums and cylinders let the complex appear to be a temple in a modern metropolis.

Bei der Überbauung des Place du Marché-Saint-Honoré hat Bofill zwei großflächig verglaste Gebäudezeilen so mit einem Satteldach zusammengefasst, dass eine Passage in ihrer Mitte entstand. Giebelfelder und Rundpfeiler lassen den Komplex mit seinen Geschäften und Büros als Tempel einer modernen Großstadt erscheinen.

Lors de la couverture de la Place du Marché-Saint-Honoré, Bofill a réuni deux lignes de bâtiments en verre de grande envergure par un toit en pente, de sorte qu'un passage soit créé en leur milieu. Des champs de fronton et des piliers ronds confèrent au complexe avec ses magasins et ses bureaux l'effet d'un temple de grande ville moderne.

En la superestructura de la Place du Marché-Saint-Honoré, Bofill ha reunido dos hileras de amplios edificios acristalados con una cubierta de dos vertientes creando un paso entre ambos. Los frontispicios y los pilares redondos hacen que el complejo con sus comercios y oficinas aparezca como templo de una gran ciudad moderna.

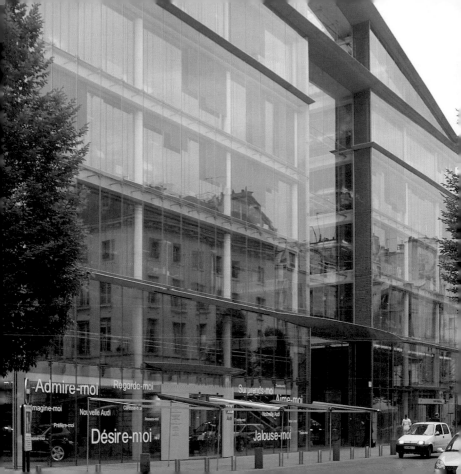

Cœur Défense

Jean-Paul Viguier

2001
Esplanade de La Défense
La Défense

www.viguier.com

The new heart-piece on Esplanade de La Défense convinces through the subdivision of the enormous amount of structural mass into one cross-member and two high as well as three low panes that run diagonally to the cross-member. A uniform pane facade-design, rounded off toward the Esplanade, provides optical cohesion.

Das neue Herzstück an der Esplanade de La Défense überzeugt durch die Aufgliederung der enormen Baumasse in einen Riegel und zwei hohe sowie drei niedrige Scheiben, die quer zu dem Riegel verlaufen. Die einheitliche Fassadengestaltung der zur Esplanade hin abgerundeten Scheiben sorgt für den optischen Zusammenhalt.

Le nouveau pièce cœur sur l'Esplanade de La Défense convainc par la division de l'énorme masse de construction en une barre et deux disques en hauteur ainsi que trois disques bas se déployant transversalement vers la barre. L'aménagement unitaire de la façade des disques arrondis et tournés sur l'Esplanade contribue au soutien optique.

El nuevo centro en la Esplanade de La Défense convence gracias a la subdivisión de enormes dimensiones en un parteluz y dos vidrieras altas y tres bajas que corren en sentido transversal al parteluz. La estructura única de la fachada de las vidrieras redondeadas hacia la Esplanade proporciona una unión óptica.

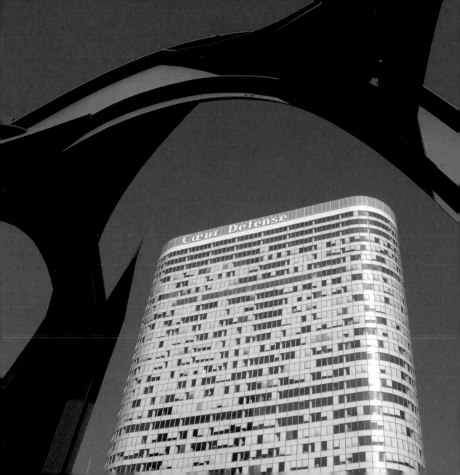

Exaltis Tower

Bernardo Fort-Brescia
Arquitectonica

2005
1, place de la Coupole
La Défense

www.arquitectonica.com

With a height of only 70 m, the 15-storey office building counts among the smallest in La Défense. Two arched sides, one convex and one concave, suggest that during a fierce motion the block pushed itself between the surrounding developments.

Mit einer Höhe von nur 70 m gehört das 15-stöckige Bürogebäude zu den kleineren in La Défense. Zwei gewölbte Seiten, eine konvexe und eine konkave, suggerieren, dass sich der Block in heftiger Bewegung zwischen die umgebende Bebauung geschoben hat.

Malgré sa hauteur de seulement 70 m, le bâtiment de 15 étages fait partie des plus petits dans le quartier de la Défense. Deux faces bombées, l'une convexe et l'autre concave, suggèrent que le bloc s'est glissé dans un mouvement violent entre les constructions environnantes.

El edificio de oficinas de 15 plantas, con una altura de sólo 70 m pertenece a los más pequeños de La Défense. Dos partes abovedadas, una convexa y otra cóncava, sugieren que el edificio se ha metido, con un movimiento brusco, entre las construcciones circundantes.

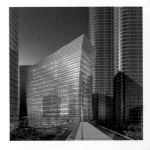

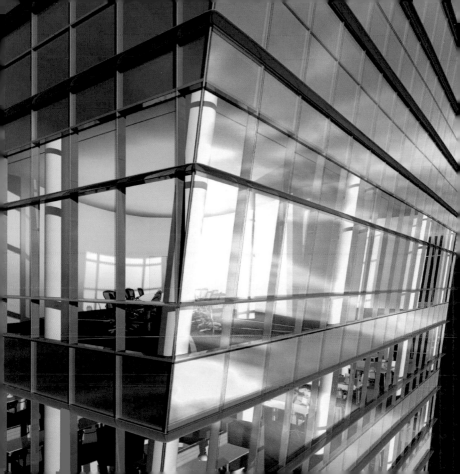

La Grande Arche

Johann-Otto von Sprekelsen (Conception, Competition)
Association avec Paul Andreu (Architecture)

1989
1, parvis de la Défense
La Défense

www.grandearche.fr
www.esplanadefence.fr
www.paul-andreu.com

At the end of the 1.4 km Parvis, stands the "great arch" that continues the series of triumphal arches on the king's axis. The "arch" consists of two narrow lateral high-rises, a connecting roof with exhibition space, and a gigantic stairway. In this room, which is slanted toward the middle, hangs the "cloud" designed to be made of glass.

Am Ende des 1,4 km langen Parvis, steht der „Große Bogen", der die Reihe der Triumphbögen auf der Königsachse fortsetzt. Der „Bogen" besteht aus zwei schmalen seitlichen Hochhäusern, einem sie verbindenden Dach mit Ausstellungsflächen und einer gigantischen Treppe. In diesem zur Mitte abgeschrägten Rahmen hängt die aus Glas geplante „Wolke".

Au bout du parvis d'1,4 km de long, se dresse la « Grande Arche », qui poursuit la série des arcs de triomphe sur l'axe royal. L'« Arche » est constituée de deux hauts immeubles étroits sur les côtés, d'un toit reliant ceux-ci avec des surfaces d'expositions et un escalier gigantesque. Dans ce cadre incliné vers le milieu est suspendu le « nuage » planifié en verre.

Al final de Parvis de 1,4 km de largo, se sitúa el "Gran Arco", que extiende la línea del Arco del Triunfo sobre el eje del Arco del Rey. El "Arco" consiste en dos edificios altos estrechos y laterales, una cubierta que los conecta con superficies de exposición y una escalera gigante. En este marco achaflanado en la mitad cuelga la "nube" prevista de cristal.

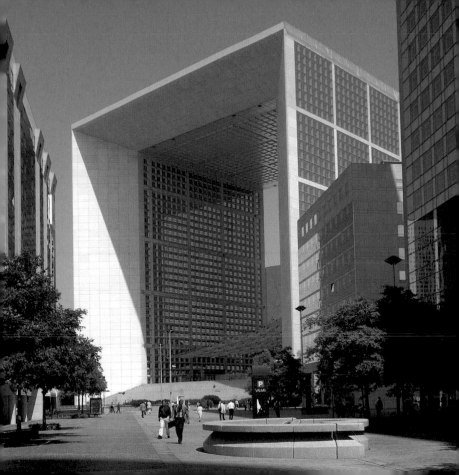

Tour EDF - Electricité de France

EDF Tower - Power supply company

Henry Cobb (Pei Cobb Freed and Partners)

2001
20, place de la Défense
La Défense

www.edf.fr
www.pcfandp.com

Similar to the Grande Arche, the high-rise also leans seven degrees out of the Esplanade axis. With its focal point, a projecting roof with a diameter of 20 meters marks the point at which both axes cross in front of the entrance. The cut at the peak of the structure produced by this projection comes to an upward end in a concave facade surface.

Wie die Grande Arche neigt sich auch das Hochhaus sieben Grad aus der Achse der Esplanade. Ein Vordach mit einem Durchmesser von 20 Metern markiert mit seinem Mittelpunkt die Stelle, an der sich vor dem Eingang die beiden Achsen kreuzen. Der Einschnitt, den dieses Vordach an der Spitze des Baukörpers verursacht, läuft nach oben in einer konkaven Fassadenfläche aus.

Comme la Grande Arche, le haut immeuble est également incliné à sept degrés au départ de l'axe de l'Esplanade. Un avant-toit de 20 mètres de diamètre marque en son centre l'endroit ou se croisent les deux axes devant l'entrée. La section que cet avant-toit a provoquée à l'extrémité du corps de bâtiment s'émince progressivement vers le haut en une surface de façade concave.

Al igual que el Grande Arche, el rascacielos se inclina siete grados del eje de la Esplanade. Un colgadizo con un diámetro de 20 metros marca, con su punto central, el lugar donde se cruzan ambos ejes ante la entrada. El corte producido por el colgadizo en la punta del edificio, expira poco a poco hacia arriba en una superficie de la fachada cóncava.

Tour Pacific
et Pont Japon
Pacific tower and Japanese bridge

Kisho Kurokawa

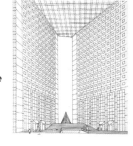

1993
11-13, cours Valmy
La Défense

www.kisho.co.jp

The gate-like building and the subsequent pedestrian bridge (a modern "Taiko Bashi") connect La Défense with Valmy over the motorway. The curved side on the motorway has a stone facade while the straight glass facade is inspired by Japanese paper doors ("Shoji"). A modern Japanese garden with a teahouse occupies the roof area.

Das torförmige Gebäude und die anschließende Fußgängerbrücke (eine moderne „Taiko Bashi") verbinden La Défense über die Autobahn hinweg mit Valmy. Die gebogene Seite an der Autobahn hat eine Steinfassade, während die gerade Glasfassade von japanisch Papiertüren („Shoji") inspiriert ist. Ein moderner japanischer Garten mit Teehaus nimmt die Dachfläche ein.

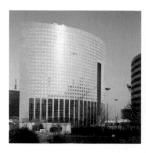

Le bâtiment en forme de portail et le pont piétonnier qui le prolonge (« Taiko Bashi » moderne) relient La Défense à Valmy au-delà de l'autoroute. Le côté incurvé sur l'autoroute a une façade de pierre alors que la façade en verre droite est inspirée des portes en papier japonais (« Shoji »). Une moderne jardin japonais avec maison de thé est aménagée sur la surface du toit.

El edificio en forma de puerta y el puente para peatones inmediatamente posterior (moderno "Taiko Bashi") unen La Défense sobre la autopista con Valmy. El lateral curvado en la autopista tiene una fachada de piedra, mientras que la recta fachada de cristal está inspirada en las puertas de papel japonesas ("Shoji"). La superficie del tejado la ocupa una moderna jardín japonés.

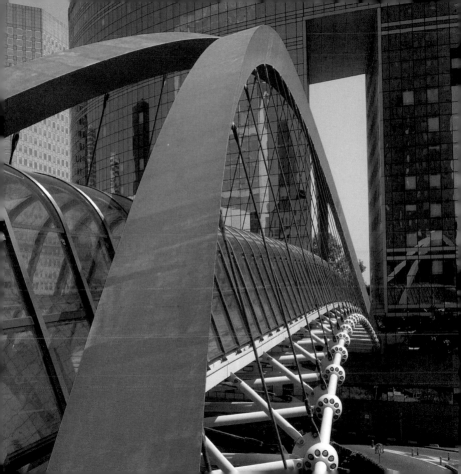

Tour t1

Denis Valode & Jean Pistre

2005
La Défense

www.valode-et-pistre.com

The arched contours of the 185 m high tower present themselves like an inflated sail. A horizontally vaulted facade on the side of the office city integrates the building into the group of high-rises situated there; a vertically vaulted one swings from the peak to the lower structure lying behind it.

Die bogenförmigen Außenlinien des 185 m hohen Turms erscheinen wie ein aufgeblasenes Segel. Eine horizontal gewölbte Fassade an der Seite der Bürostadt gliedert den Bau in die Gruppe der dortigen Hochhäuser ein, eine vertikal gewölbte schwingt sich von der Spitze zur dahinter liegenden niedrigeren Bebauung hinab.

Les lignes extérieures de la tour de 185 m de haut apparaissent comme une voile gonflée. Une façade bombée horizontalement sur le côté de la cité des bureaux intègre la construction dans le groupe des hauts immeubles qui s'y trouvent, une bombée verti-calement oscille de la pointe à la construction arrière située plus bas.

Las líneas externas en forma de arco de la torre de 185 m aparecen como una vela al viento. Una fachada horizontal arqueada en el lateral de la ciudad de oficinas integra la construcción en el grupo de los rascacielos circundantes, una fachada vertical arqueada va desde la punta hasta la estrecha construcción situada en la parte trasera.

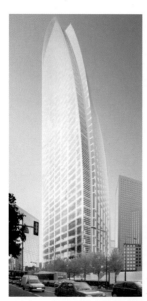

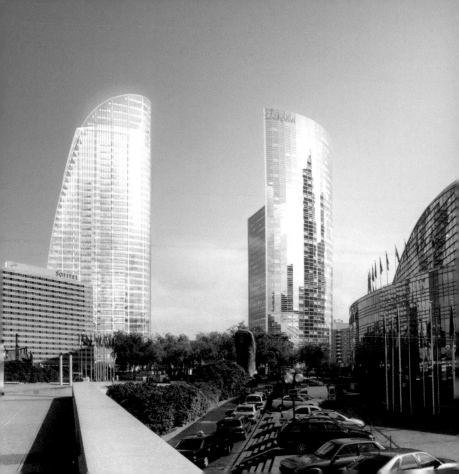

Le Grand Louvre

Ieoh Ming Pei, Michel Macary, Pei Cobb Freed and Partners,
Georges Duval, Jean-Michel Wilmotte

2000
99, rue de Rivoli
Place du Carrousel
1. Arrondissement

www.louvre.fr
www.pcfandp.com

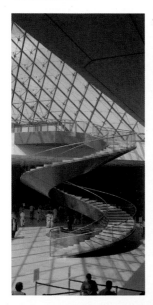

Architectural history could be observed at the Louvre since the end of the 12th century. The last museum expansion was between 1983 and 2000: The so-called Richelieu wing is now utilized as a museum and a pyramid has arisen as a new entrance in the large courtyard with a large underground shopping- and dining-mall.

Am Louvre lässt sich Architekturgeschichte seit Ende des 12. Jahrhunderts betrachten. Zuletzt wurde das Museum von 1983 bis 2000 erweitert: Der sogenannte Richelieu-Flügel dient nun ebenfalls als Museum und im großen Hof entstand die Pyramide als neuer Eingang, mit einer großen unterirdischen Laden- und Gastronomie-Passage.

Au Louvre, il est possible de consulter l'histoire de l'architecture depuis la fin du 12e siècle. Le musée a été agrandi enfin de 1983 à 2000 : L'aile Richelieu sert désormais également de musée et dans la grande cour ne se trouve pas seulement la Pyramide comme nouvelle entrée, mais aussi une extension souterraine avec une galerie marchande et des possibilités de restauration.

En el Louvre es posible contemplar la historia de la arquitectura desde finales del siglo XII. El museo fue ampliado desde 1983 hasta 2000: el ala Richelieu sirve incluso como museo y en el gran patio no sólo se ha erigido la Pirámide como una nueva entrada sino también una ampliación subterránea con un paso para comercios y restaurantes.

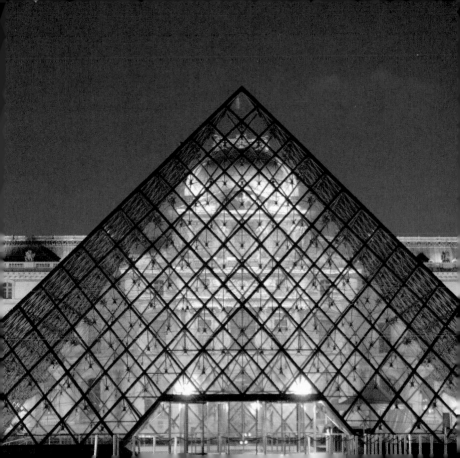

to see . culture & education: 14

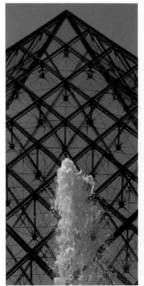

42

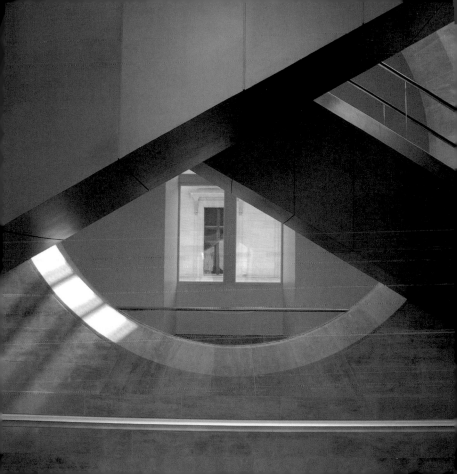

Pavillon de l'Arsenal

The arsenal pavilion

Christian Biecher (Video room)
A. Clément (Architecture)

2002 (Video room)
1879 (Architecture)
21, boulevard Morland
4. Arrondissement

www.pavillon-arsenal.com
www.biecher.com

The Centre d'Urbanisme et d'Architecture de la Ville de Paris is the first stop in the city for those interested in architecture. Along with alternating exhibitions and a permanent presentation, the video library informs one about the architectural creations in the city. It is made of shining sweeping partitions that create cabins.

Das Centre d'Urbanisme et d'Architecture de la Ville de Paris ist erste Anlaufstelle des Architekturinteressierten in der Stadt. Neben wechselnden Ausstellungen und einer Dauerpräsentation informiert die Videobibliothek über das architektonische Schaffen in der Stadt. Sie besteht aus leuchtenden, geschwungenen Trennwänden, die Kabinen schaffen.

Le Centre d'Urbanisme et d'Architecture de la Ville de Paris est le premier point d'information des intéressés en architecture dans la ville. Outre diverses expositions variant et une présentation permanente, la bibliothèque vidéo propose des informations sur la création architectonique de la ville. Elle est composée de cloisons lumineuses pivotantes qui créent des cabines.

El Centre d'Urbanisme et d'Architecture de la Ville de París es el primer servicio de atención para los aficionados a la arquitectura de la ciudad. Junto con las exposiciones itinerantes y una presentación permanente, la videoteca informa sobre las creaciones arquitectónicas de la ciudad. Se compone de paredes divisorias con iluminación oscilante que crean cabinas.

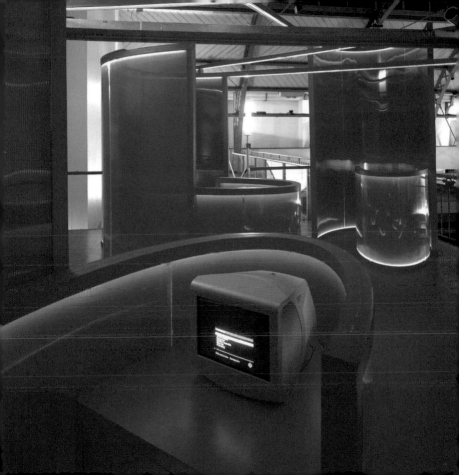

Rénovation
Centre Georges-Pompidou
Restoration

Renzo Piano (The Forum, Atelier Brancusi)
Périphériques, Emmanuelle Martin-Trottin,
David Trottin (Exhibition room for graphic arts)
Richard Rogers, Renzo Piano, Gianfranco Franchini (Original building)

2002 (Exhibition room)
2000 (Atelier)
1977 (Original building)
19, rue Beaubourg
4. Arrondissement

www.cnac-gp.fr
www.rpwf.org
www.peripheriques-architectes.com
www.richardrogers.co.uk

If, in its time, the Centre was as controversial as the Eiffel Tower, it is presently not only a lively part of the quarter but has also become an eye catcher in the Paris cityscape. In the annexes and extensions, Piano appears to have been transformed into a "new elegance".

War das Centre seinerzeit umstritten wie der Eiffelturm, ist es heute nicht nur lebendiger Bestandteil des Quartiers, sondern auch Blickfang im Pariser Stadtbild geworden. Bei den An- und Ausbauten zeigt Piano sich zur „Neuen Eleganz" gewandelt.

Alors que le Centre était aussi controversé que la tour Eiffel à l'époque de sa construction, il n'est pas seulement devenu partie intégrante vivante du quartier, mais aussi un objet qui accroche le regard dans le paysage citadin de Paris. Dans ses constructions annexes et d'extensions, Piano se montre tourné vers la « nouvelle élégance ».

Este centro, que en su época fue igual de controvertido que la Torre Eiffel, es hoy no sólo un elemento lleno de vida dentro de este distrito, sino también un foco de atención del aspecto urbano global de París. Los anexos y las ampliaciones reflejan el vuelco que Piano ha dado hacia la llamada "nueva elegancia".

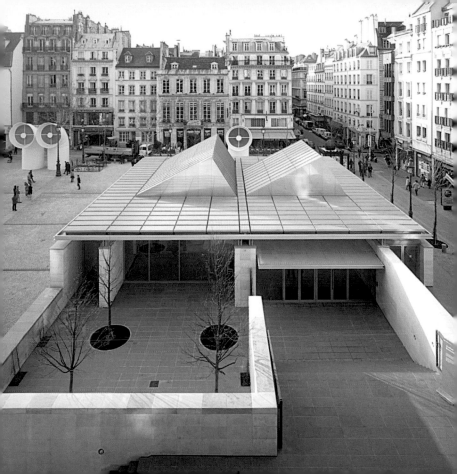

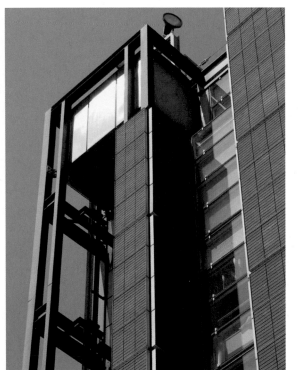

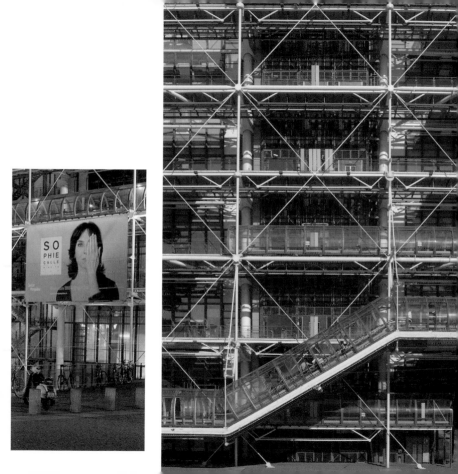

Institut du Monde Arabe

The Arab Institute

Jean Nouvel
Architecture Studio
Gilbert Lézenès
Pierre Soria

1987
1, rue des Fossés-Saint-Bernard
5. Arrondissement

www.imarabe.org
www.architecture-studio.fr
www.jeannouvel.com

The "Grand Projet" from the Mitterrand era has an extensive glass facade on the side facing the Seine. Iris diaphragms serve as shading, which automatically regulate the amount of penetrating light, depending on the sunshine. Their orderly but varied structure reminds one of Quamrya, the window fillings of the Islamic architecture of Egypt.

Das „Grand Projet" der Ära Mitterrand hat an der, der Seine abgewandten Seite eine großflächige Glasfassade. Zur Verschattung dienen Irisblenden, die je nach Sonneneinstrahlung die eindringende Lichtmenge automatisch regeln. Ihre regelmäßige aber variierte Struktur erinnert an Quamrya, die Fensterfüllungen der islamischen Baukunst Ägyptens.

Le « Grand Projet » de l'Ere Mitterrand est pourvu sur le côté tourné sur la seine d'une façade en verre de surface étendue. Des panneaux d'iris servent à ombrager, et régulent automatiquement en fonction des rayons du soleil la quantité de lumière pénétrante. Leur structure régulière mais variée rappelle Quamrya, la garniture de fenêtres de l'art architectural islamique égyptien.

El "Grand Projet" de la era Mitterrand tiene una amplia fachada de cristal en la orilla apartada del Sena. Los diafragmas iris sirven para dar sombra. Estos diafragmas regulan automáticamente la cantidad de luz que penetra según la radiación solar. Su estructura regular aunque variada recuerda a Quamrya, las cristaleras del arte arquitectónico islámico de Egipto.

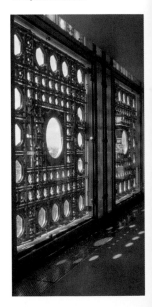

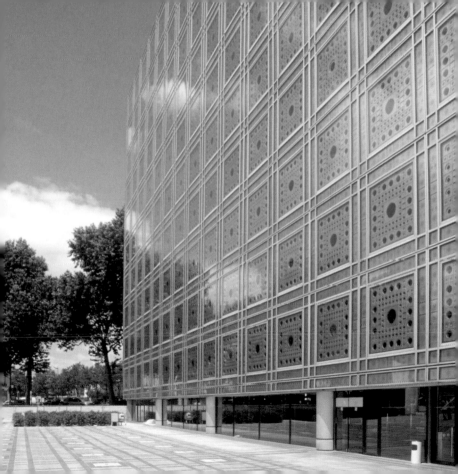

Musée du Quai Branly

Museum

Jean Nouvel (Architecture)
Gilles Clément (Landscape)

2005
Quai Branly
7. Arrondissement

www.quaibranly.fr
www.jeannouvel.com

The art exhibits from non-European cultures previously spread out among various museums will be reunited in the new construction. The spacious relocation of the building, which takes up motifs of the rainforest and savannah, frees the arriving visitor from the context of the West-European Seine metropolis and provide a transition to the displayed cultural areas.

Die bisher auf verschiedene Museen verteilten Exponate der Künste außereuropäischer Kulturen werden in dem Neubau zusammengeführt. Die großräumige Umpflanzung, die Motive des Regenwaldes und der Savanne aufgreift, löst den ankommenden Besucher aus dem Kontext der westeuropäischen Seine-Metropole und leitet zu den gezeigten Kulturräumen über.

Les pièces d'expositions des cultures non européennes réparties jusqu'à présent sur divers musées seront rassemblées dans la nouvelle construction. La transplantation de grande envergure, qui reprend les motifs de la forêt vierge et de la savane enlève le visiteur qui arrive du contexte de la métropole d'Europe occidentale sur les bords de la Seine et le guide aux espaces culturels exposés.

Las obras expuestas del arte de culturas no europeas distribuidas hasta ahora en diferentes museos se reunirán en el nuevo edificio. La espaciosa planta, captura los motivos de la selva tropical y de la savana, separa al visitante que llega del contexto de la metrópoli del Sena del oeste de Europa y le conduce a las salas de cultura exhibidas.

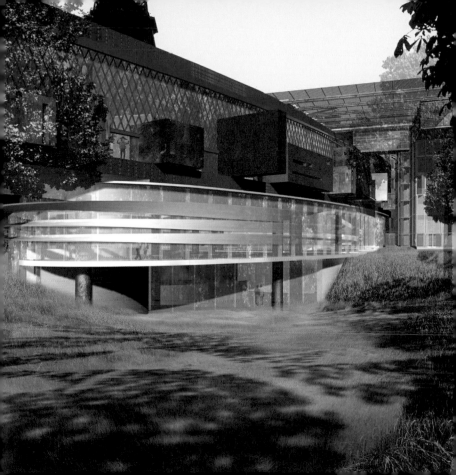

UNESCO

Pavillon de la Méditation
Square de la Tolérance en Hommage a Yitzhak Rabin

Tadao Ando (Pavilion)
Dani Karavan (Square)
Pier Luigi Nervi, Marcel Breuer, Bernhard Zehrfuss (UNESCO)

1996 (Pavillon, Square)
1958 (UNESCO)
Place de Fontenoy
7. Arrondissement

www.unesco.org/visit/uk/v4
www.pritzkerprize.com/andorel.htm

The headquarters of the world culture organisation is surrounded by various smaller complexes. Along with the "Garden of Peace" and "Square of Tolerance", a meditation pavilion made of concrete and Hiroshima-granite is found here. Its interdenominational character corresponds to the fundamental idea of a worldwide active organisation.

Der Sitz der Weltkulturorganisation wird von verschiedenen kleineren Komplexen umgeben. Neben dem „Friedensgarten" und dem „Platz der Toleranz" befindet sich hier ein Meditationspavillon aus Beton und Hiroshima-Granit. Sein überkonfessioneller Charakter entspricht dem Grundgedanken einer weltweit tätigen Organisation.

Le siège de l'organisation culturelle mondiale est entouré de divers complexes plus petits. A côté du « Jardin de la paix » et du « Square de la tolérance » s'y trouve un pavillon de méditation en béton et en granit d'Hiroshima. Son caractère supraconfessionnel correspond à la pensée fondamentale d'une organisation active internationalement.

La sede de la organización mundial de la cultura estará rodeada por diferentes pequeños complejos. Junto al "Jardín de la paz" y a la "Plaza de la Tolerancia" se encuentra un pabellón de meditación de cemento y granito de Hiroshima. Su carácter supraconfesional corresponde a los principios fundamentales de una organización de acción mundial.

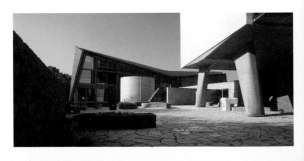

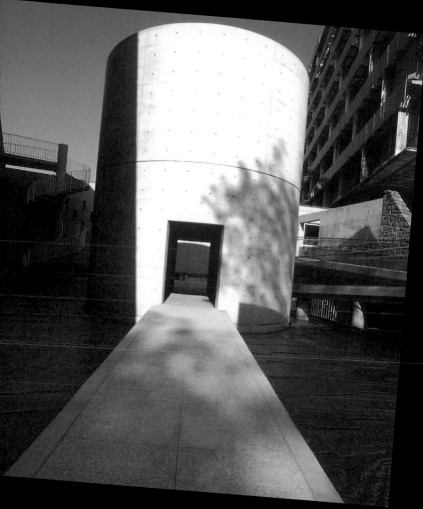

Bibliothèque nationale de France Site François Mitterrand

French National Library

Dominique Perrault

1996
Quai François-Mauriac
13. Arrondissement

www.bnf.fr
www.perraultarchitecte.com

The four book towers on the corners of the Bibliothèque nationale de France are visible from far off. The reading rooms create a planted inner courtyard under them. These halls are not visible from the Seine but are concealed by numerous steps, which awaken an association with a Krepis—an ancient terraced understructure—surrounding the book temple.

Die vier Büchertürme auf den Ecken der Bibliothèque nationale de France sind von weitem sichtbar. Unter ihnen bilden die Lesesäle einen begrünten Innenhof. Diese Säle sind von der Seine aus nicht sichtbar, sondern werden von zahlreichen Stufen verdeckt, die die Assoziation einer umlaufenden Krepis – eines antiken Stufenunterbaus – des Büchertempels erwecken.

Les quatre tours livresques sur les angles de la Bibliothèque nationale de France sont visibles de loin. Au-dessous de celles-ci, les salles de lectures constituent une cour intérieure verdie. Ces salles ne sont pas visibles des rives de la Seine, mais elles sont dissimulées par différents paliers qui éveillent l'association d'un « Krepis » sur le pourtour, une sous-construction antique, du temple du livre.

Las cuatro torres de libros en las esquinas de la Bibliothèque nationale de France pueden verse desde lejos. Debajo de ellas, las salas de lectura crean un patio interior ajardinado. Dichas salas no pueden verse desde la orilla del Sena, sino que están cubiertas por numerosas gradas, que despierta la asociación de un crepis circular, una antigua base de gradas, del templo de los libros.

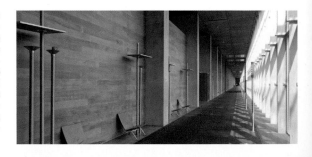

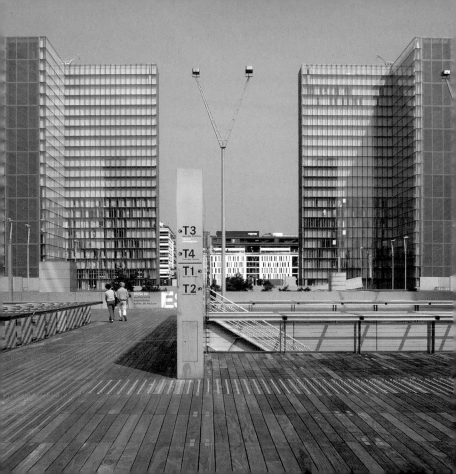

Fondation Cartier
pour l'Art Contemporain

Cartier Foundation for Contemporary Art

Jean Nouvel, Emanuel Cattani et Associés (Architecture)

1994
261, boulevard Raspail
14. Arrondissement

www.fondation.cartier.fr
www.jeannouvel.com

The foundation building—half office building, half museum—is an extensively glassed-in frame structure with two facades. The actual structure lies recessed on the property, a second glass wall that is not identical lies on the road building-line.

Das Stiftungsgebäude – halb Bürogebäude, halb Museum – ist eine großflächig verglaste Rahmenkonstruktion mit zwei Fassaden. Der eigentliche Baukörper liegt zurückgesetzt auf dem Grundstück, eine zweite nicht deckungsgleiche Glaswand auf der Straßenflucht.

Le bâtiment de la fondation – pour moitié immeuble de bureaux, pour moitié musée – est une construction de cadre en verre sur de grandes surfaces avec deux façades. Le corps de bâtiment propre se trouve en retrait sur le terrain, une deuxième cloison en verre non coïncidente loin en avant sur la fuite de rue.

El edificio de la fundación, mitad edificio de oficinas, mitad museo, es una amplia estructura porticada y acristalada, con dos fachadas. La estructura real se sitúa hacia atrás sobre el terreno, una segunda pared de cristal que no está cubierta de igual forma está más alejada sobre el flujo de la calle.

Musée national des Arts asiatiques-Guimet

National Museum of Asian Arts

Henri et Bruno Gaudin (Renovation)
Jules Chatron (Original building)

2001 (Renovation)
1888 (Original building)
6, place d'Iéna
16. Arrondissement

www.museeguimet.fr

The reshaping of the museum tries to create a suitable stage for the most important exhibits. Uniform white serves as a neutral background in front of which the architectural structures and the lighting control of the individual objects are emphasised. From the winding stairway, one can see into the various collection compartments.

Die Neugestaltung des Museums versucht, den wichtigsten Exponaten eine angemessene Bühne zu verschaffen. Einheitliches Weiß dient als neutraler Hintergrund, vor dem architektonische Strukturen und die Lichtregie das Einzelobjekt herausstellen. Vom gewundenen Treppenhaus aus sieht man in die verschiedenen Sammlungsabteilungen.

Le nouvel aménagement du musée tente de donner aux objets d'exposition les plus importants une scène adaptée. Un blanc unitaire sert d'arrière-plan neutre, en avant duquel les structures architectoniques et la régie des lumières mettent en relief l'objet individuel. De la cage d'escalier hélicoïdale, on peut voir les différents rayons de la collection.

La nueva disposición del museo intenta crear un escenario adecuado para las obras expuestas de mayor importancia. El blanco uniforme sirve como fondo neutro, ante el cual las estructuras arquitectónicas y el juego de luces resaltan el objeto aislado. Desde las serpenteantes escaleras se ven las diferentes secciones de las colecciones.

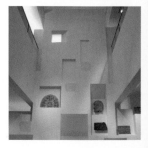

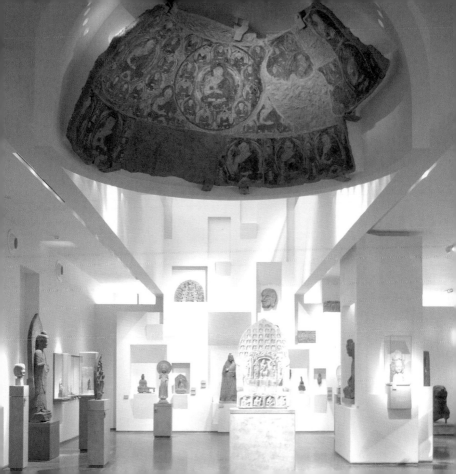

Site de création contemporaine Paris musée

Palais de Tokyo

Anne Lacaton & Jean-Philippe Vassal (Renovation)
Jean-Claude Dondel, André Aubert, Paul-Jean-Emile Viard,
Marcel Dastugue (Original building)

2002 (Renovation)
1937 (Original building)
13, avenue du Président Wilson
16. Arrondissement

www.palaisdetokyo.com

This altered section of the museum's contemporary art belongs to the most sensational projects in the city. As only a small budget was available, the architects decided to refurbish the substance as much as possible and to invest in preservation. The "construction site" creates a workshop atmosphere suitable to modern art.

Dieser Umbau des Museums zeitgenössischer Kunst gehört zu den Aufsehen erregendsten Projekten der Stadt. Da nur ein geringes Budget zur Verfügung stand, entschlossen sich die Architekten, die Substanz soweit als möglich zu sanieren und in die Erhaltung zu investieren. Die „Baustelle" schafft eine der modernen Kunst angemessene Werkstattatmosphäre.

Ce réaménagement du Musée d'arts contemporains fait partie des projets les plus remarquables de la ville. Etant donné que seulement un budget faible a été mis à disposition, les architectes ont décidé de rénover le plus possible la substance et d'investir dans la conservation. Le « chantier » crée une atmosphère d'atelier digne de l'art moderne.

Esta reconstrucción del Museo de Arte Contemporáneo pertenece a los proyectos más espectaculares de la ciudad. Dado que se disponía únicamente de un presupuesto mínimo, los arquitectos decidieron sanear lo esencial en la medida de lo posible e invertir en la conservación. El "terreno" proporciona una atmósfera apropiada para el estudio del arte moderno.

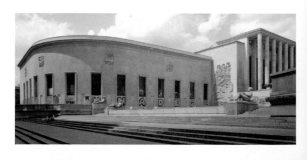

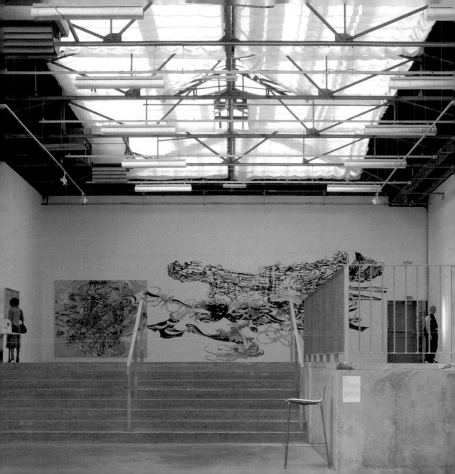

Conservatoire National Supérieur de Musique
et de Danse de Paris

Cité de la Musique

Paris national superior conservatory for music and dance

Christian de Portzamparc (Architecture Cité de la Musique, Academy)
Franck Hammoutène (Musée de la Musique)

1995 (Cité de la Musique, Academy)
1997 (Musée de la Musique)
213-221, avenue Jean-Jaurès
19. Arrondissement

www.cite-musique.fr
www.cnsmdp.fr
www.chdeportzamparc.com

The "Grands Projets" of Cité de la Musique and the Conservatoire flank the Parc de la Villette on the city side. The basic form of the Cité was inspired by the cave of Dionysios I by Syrakus (405-367 BC). This had the form of a spiral, which carried the singing of the slaves outside. The town house facades of the interior fall back on the term "Cité".

Die „Grands Projets" der Cité de la Musique und des Conservatoire flankieren den Parc de la Villette an der Stadtseite. Die Grundform der Cité ist von der Höhle des Dionysios I. von Syrakus (405-367 v. Chr.) inspiriert. Diese hatte die Form einer Spirale, die den Gesang der Sklaven nach außen trug. Die Stadthaus-Fassaden des Inneren greifen die Bezeichnung „Cité" auf.

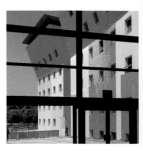

Les Grands Projets de la Cité de la Musique et du Conservatoire flanquent le Parc de la Villette sur le côté de la ville. La forme de base de la Cité est inspirée de la caverne de Dionysos Ier de Syracuse (405-367 av. J. C.). Celle-ci a la forme d'une spirale qui portait le chant des esclaves vers l'extérieur. Les façades d'édifice municipal reçoivent la désignation de « Cité ».

Los "Grands Projects" de la Cité de la Musique y del Conservatorio flanquean el Parc de la Villette por el lado de la ciudad. La forma básica de la Cité se halla inspirada en la cueva de Dionisio I de Siracusa (405-367 a.C.), que tenía forma de espiral para transmitir hacia afuera el canto de los esclavos. Las fachadas del interior al estilo de las casas urbanas retoman el tema de la "Cité".

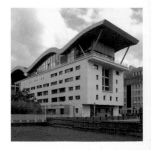

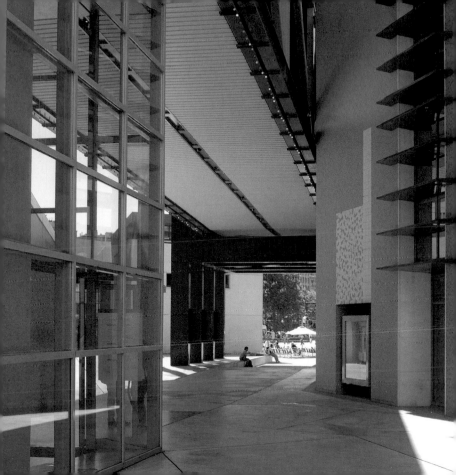

Cité des Sciences et de l'Industrie

House of Science and Industry

Adrien Fainsilber (Architecture)

1987
30, avenue Corentin-Cariou
19. Arrondissement

www.cite-sciences.fr
www.fainsilber.com

Planned as the main slaughter-house for Paris, the abandoned construction was redesigned to become a huge interactive museum for technology and industry. The main hall offers space for large objects. In the geodetic dome—a column-free supporting structure made of flat faces of a cupola—an all-around cinema is found.

Als zentraler Schlachthof für Paris geplant, wurde die Bauruine zu einem riesigen, interaktiven Museum der Technik und Industrie umgestaltet. Die zentrale Halle bietet großen Objekten Raum. Im geodätischen Dom – einem stützenfreien Tragwerk aus den flachen Facetten einer Kuppel – befindet sich ein Rundumkino.

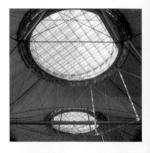

Alors qu'elle était prévue comme abattoir central pour Paris, la construction en ruines a été aménagée un gigantesque musée interactif de la technique et de l'industrie. La halle centrale offre de l'espace aux grands objets. Un cinéma à 360° se trouve dans le dôme géodésique – une structure de fondations sans contreforts en facettes plates d'une coupole.

Planeada originalmente como matadero central de París, esta construcción en ruinas fue remodelada como un enorme museo interactivo sobre la técnica e industria. La sala alberga objetos de gran tamaño. En el domo geodésico –una estructura portante sin pilares compuesta por los biseles planos de una cúpula– se ha instalado un cine de 360°.

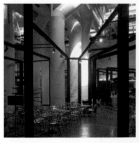

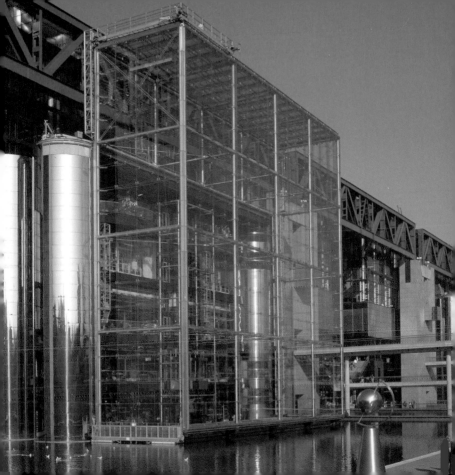

Fondation d'art contemporain François Pinault

Foundation of Contemporary Art

Tadao Ando

2007
Île Seguin
Boulogne-Billancourt

www.pritzkerprize.com/andorel.htm

On an inland of the Seine with a Renault factory out of operation since 1992, the museum with 32.000 m² of exhibition space for a gigantic private collection of modern art is coming into being. Next to a park and an office- and residential city, the museum will occupy the tip of the island.

Auf einer Seine-Insel mit einer seit 1992 stillgelegten Renault-Fabrik entsteht das Museum mit 32.000 m² Ausstellungsfläche für eine riesige Privatsammlung moderner Kunst. Neben einem Park und einer Büro- und Wohnstadt wird das Museum die Spitze der Insel einnehmen.

C'est sur une île de la Seine avec la régie Renault fermée depuis 1992 que sera ouvert le musée avec 32.000 m² de surface d'exposition pour une immense collection privée d'art moderne. A côté d'un parc, d'une cité de bureaux et d'habitations, le musée va prendre la pointe de l'île.

En una de las islas del Sena, donde se encuentra una fábrica de Renault cerrada desde 1992, se tiene planeado edificar este museo, que dispondrá de una superficie de exposición de 32.000 m² para una impresionante colección privada de arte contemporáneo. Junto a un parque y una ciudad de oficinas y vivrendas, el museo ocupará le punta de la isla.

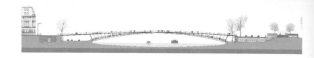

Passerelle Solférino

Marc Mimram

1999
Quai de Tuileries /
Quai Anatole-France
1. Arrondissement

www.mimram.com

The pedestrian bridge made of wood and steel closes the gap in the otherwise dense series of Seine crossings. At each one, an arch crosses over the river at wharf- or bank level. Both bridge arches fuse at the apex into a vertical "crossroads", upon which four streets converge. It is thus possible to walk down or climb up one level.

Le pont piétonnier en bois et en acier ferme un vide dans la suite sinon dense des traversées de la Seine. Respectivement un arc traverse le fleuve à hauteur des quais ou des rives. Les deux arcs de pont se fusionnent à la clé de voûte en un « carrefour » vertical sur lequel aboutissent les quatre routes. Il est ainsi ici possible de monter ou de descendre sur un plan.

Die Fußgängerbrücke aus Holz und Stahl schließt eine Lücke in der sonst dichten Folge der Seine-Überquerungen. Je ein Bogen überquert den Fluss auf Kai- bzw. auf Uferhöhe. Beide Brückenbögen verschmelzen im Scheitel zu einer vertikalen „Kreuzung", auf die vier Straßen münden. So ist es hier möglich eine Ebene hinabzusteigen oder hinaufzugehen.

El puente peatonal de madera y acero completa un espacio vacío en la sino estrecha secuencia de puentes que unen ambas orillas del Sena. Un arco cruza el río a la altura de los atracaderos y otro a la de la orilla. Ambos arcos del puente se unen en el vértice dando lugar a un "cruce", en el que desembocan cuatro calles. Esto permite subir o bajar un nivel, respectivamente.

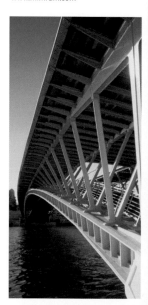

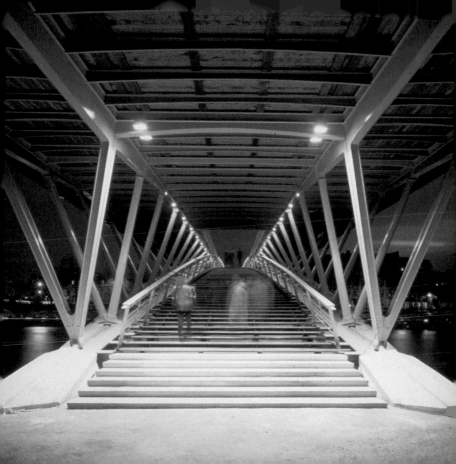

Mur pour la Paix

Wall for Peace

Jean-Michel Wilmotte, Clara Halter (Wall)
Jaques-Ange Gabriel (École Militaire)

2001 (Wall)
1782 (École Militaire)
Parc du Champ de Mars /
Place Joffre
7. Arrondissement

www.wallforpeace.com

The "Wall for Peace" stands on a drill field named after Mars, the god of war, in front of the military academy. With inscriptions in 32 languages, peace is thus called for. The columns and horizontal elements of the lightweight "wall" stand in opposition to the facade structure of the École Militaire in the distance.

Die „Mauer für den Frieden" steht auf einem nach dem Kriegsgott Mars benannten Exerzierfeld vor der Militärakademie. Mit Inschriften in 32 Sprachen wird der Frieden angemahnt. Die Säulen und horizontalen Elemente der leichten „Mauer" stehen im Gegensatz zu der schweren Fassadenstruktur der École Militaire in der Ferne.

Le « Mur pour la Paix » se trouve sur un champ d'exercice nommé d'après Mars le dieu de la guerre, devant l'académie militaire. La paix est rappelée solennellement avec des inscriptions en 32 langues. Les colonnes et éléments horizontaux du « mur » léger sont placés en contraste par rapport à la lourde structure de la façade de l'École Militaire au loin.

El "muro para la paz" se ha erigido sobre un campo de maniobras ubicado delante de la academia militar, al que Marte, el rey de la guerra, le ha dado el nombre. Sus inscripciones en 32 idiomas invocan, pues, la paz. Las columnas y los elementos horizontales de este ligero "muro" constituyen el polo opuesto a la recargada fachada de la École Militaire que se divisa a lo lejos.

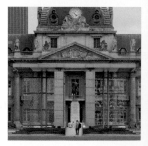

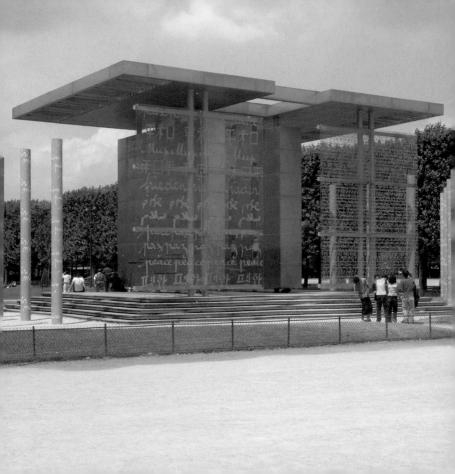

Gare du Nord

Agence des gares SNCF, Jean-Marie Duthilleul, Etienne Tricaud
Jakob Ignaz Hittorff (Original building)

2002
1865 (Original building)
Place Napoléon III
10. Arrondissement

www.sncf.com
www.arep.fr
www.oth.fr

The train station expansion continues the main motif of the old structure: Here, its fragile gable roof—on thin, 38m-high cast iron supports—is even more transparent in the new building made of modern materials. The sideways staggered-back new construction also remains unobtrusive outside.

Die Bahnhofserweiterung führt das Hauptmotiv des Altbaus fort: Dessen fragiles Satteldach – auf dünnen, 38 m hohen Gusseisenstützen – wird im Neubau aus modernen Materialien noch durchsichtiger. Auch außen bleibt der seitlich zurückgestaffelte Neubau unaufdringlich.

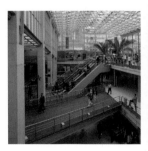

L'extension de la gare poursuit le motif principal de la construction ancienne : son toit en pente fragile reposant sur de fins supports en fer coulé de 38 m de haut y devient encore plus transparent dans la construction nouvelle en matériaux modernes. De l'extérieur également, la construction nouvelle échelonnée en retrait latéralement reste discrète.

La ampliación de la estación de ferrocarril retoma el motivo principal del edificio antiguo: Su frágil techo de dos vertientes sobre estrechos pilares de hierro fundido de 38 m de altura es aún más transparente aquí en el nuevo edificio de materiales modernos. También el exterior del edificio nuevo, escalonado hacia atrás en los laterales, es relativamente discreto.

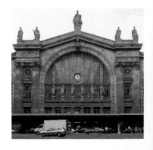

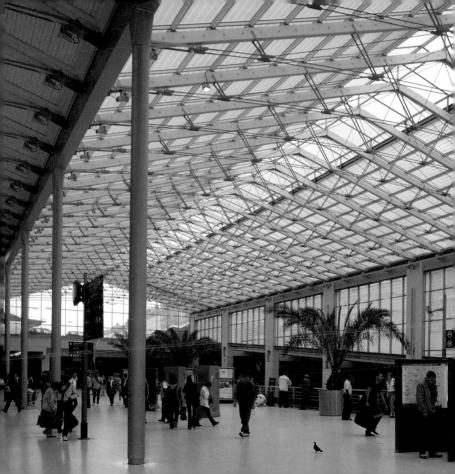

Notre-Dame-d'Espérance

Bruno Legrand (Architecture)

1998
47, rue de la Roquette /
rue du Commandant-Lamy
11. Arrondissement

The new building located at an intersection fits into the block structure of the quarter, while the tower with its powerful cross dominates all. The main decoration themes consist of inscriptions: the St. Mark-, St. Matthias-, and St. Luke-Gospels on the facade, the Gospel of St. John and the Paul Epistles in the interior as well as the Old Testament in the side street.

Der an einer Kreuzung gelegene Neubau fügt sich in die Blockstruktur des Viertels ein, während der Turm mit dem mächtigen Kreuz dieses überragt. Hauptdekorationsmotiv sind Inschriften: die Markus-, Matthäus und Lukas-Evangelien an der Fassade, Johannes-Evangelium und Paulus-Briefe im Inneren sowie das AlteTestament in der Seitenstraße.

Le nouveau bâtiment situé à un carrefour s'intègre dans la structure de bloc du quartier, pendant que le clocher à la puissante croix dépasse celui-ci. Les motifs de décoration sont de nombreuses écritures : les évangiles de Marc, Matthieu et Luc sur la façade, l'évangile de Jean et les lettres de Paul à l'intérieur ainsi que l'Ancien Testament sur la rue adjacente.

La nueva construcción situada en un cruce se integra en la estructura de bloque del barrio, mientras que la torre la sobrepasa con la poderosa cruz. El motivo decorativo son las numerosas inscripciones: los Evangelios de Marcos, Mateo y Lucas sobre la fachada, el Evangelio de Juan y las Cartas de Pablo en el interior así como el Antiguo Testamento en la calle lateral.

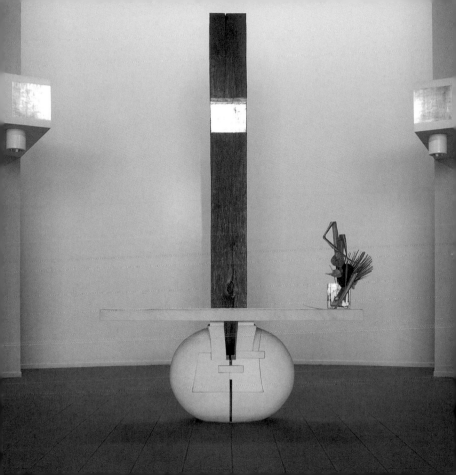

Parc de Bercy

Atelier Parisien d'Urbanisme APUR (Urban research)
Marylène Ferran, Bernhard Huet, Jean-Pierre Feugas, Bernard Leroy (Park)

1997
Quai de Bercy / rue Joseph-Kessel
12. Arrondissement

www.apur.org

The construction is part of the large scale reshaping of the municipal area, in which a large number of new residential buildings were developed. With its architectural elements, it lies like a net over the older structures. New buildings supplement the standing assets and make the park usable in manifold ways.

Die Anlage ist Teil der großflächigen Umgestaltung des Stadtgebiets, bei der eine große Anzahl neuer Wohnhäuser entstand. Sie legt sich mit seinen architektonischen Elementen als Netz über die älteren Strukturen. Neubauten ergänzen den Bestand und machen den Park vielfältig nutzbar.

L'installation fait partie du réaménagement de surface étendue de la zone municipale, pour laquelle ont été construites un grand nombre de nouvelles maisons d'habitation. Avec ses éléments architectoniques elle se pose comme un réseau sur les structures plus anciennes. Des constructions nouvelles complètent l'ensemble et rendent le parc utilisable de manière multiple.

Esta instalación forma parte de la amplia remodelación que ha sufrido la zona urbana, y que ha dado lugar a un gran número de edificios nuevos de viviendas. Con sus elementos arquitectónicos se despliega como una red sobre las estructuras más antiguas. Los edificios nuevos complementan las edificaciones ya existentes y convierten el parque en un lugar de uso muy variado.

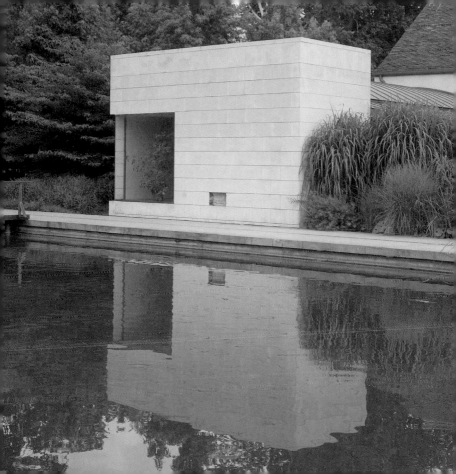

Passerelle Bercy-Tolbiac

Dietmar Feichtinger Architectes

2005
Quai François-Mauriac /
quai de Bercy
12. Arrondissement

www.feichtingerarchitectes.com

The pedestrian bridge spans a basin of the Seine. With an arch and a suspended construction, it simultaneously consists of two supporting structures, usually single in bridge building. As these systems mutually strengthen each other, the pool's 190 m can be crossed without using supports.

Die Fußgängerbrücke überspannt ein Becken der Seine. Mit einem Bogen und einer Hängekonstruktion besteht sie gleich aus zwei im Brückenbau einzeln üblichen Tragwerken. Indem sich diese Systeme gegenseitig verstärken, können die 190 m des Beckens stützenfrei überquert werden.

Le pont piétonnier passe au-dessus d'un bassin de la Seine. Avec une arche et une construction suspendue, elle est constituée simultanément de deux constructions habituellement dissociées dans la construction de ponts. Comme les deux systèmes se renforcent mutuellement, les 190 m du bassin peuvent être traversés sans appuis.

El puente peatonal cruza por encima de una dársena del Sena. Con su arco y su construcción colgante dispone de dos estructuras portantes que suelen emplearse alternativamente en la construcción de puentes. Al reforzarse mutuamente estos dos sistemas, se puede cruzar esta dársena de 190 m de longitud sin necesidad de pilares.

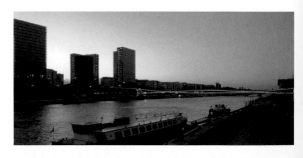

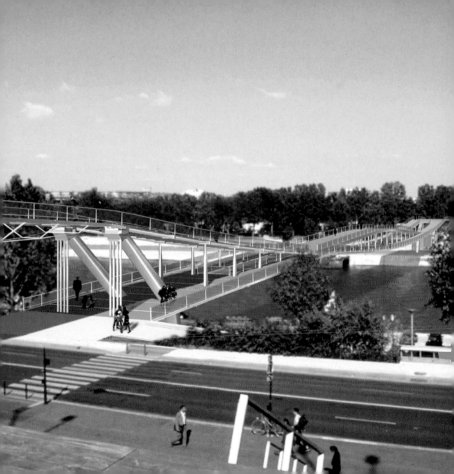

Jardin Hector Malot et Jardin de Reuilly
Promenade plantée
Landscaped promenade in the Hector Malot Garden and Reuilly Garden

Philippe Mathieux (Esplanade)
Jacques Vergely (Landscape promenade)
Andreas Christo-Foroux (Jardin Hector Malot)
Groupe Paysages, Pierre Colboc (Jardin de Reuilly)

1988 (Esplanade)
1995 (Jardin Hector Malot)
1992 (Jardin de Reuilly)
Avenue Daumesnil
12. Arrondissement

The "landscaped promenade" begins on a railroad viaduct (Le Viaduc des Arts) at Place de la Bastille and leads out of the city in the direction of Bois de Vincennes. While doing so, it incorporates other parks: the small Jardin Hector Malot and the Jardin de Reuilly with bridged green spaces, lying on a car park.

Die „bepflanzte Promenade" beginnt auf einem Eisenbahnviadukt (Le Viaduc des Arts) beim Place de la Bastille und führt in Richtung Bois de Vincennes aus der Stadt hinaus. Dabei bezieht sie andere Parkanlagen ein: Den kleinen Jardin Hector Malot und den auf einem Parkhaus gelegenen Jardin de Reuilly mit überbrückter Grünfläche.

La « Promenade plantée » commence sur un viaduc de voie ferrée (Le Viaduc des Arts) près de la Place de la Bastille et conduit hors de la ville en direction du Bois de Vincennes. Elle intègre ce faisant d'autres installations de parcs : le petit Jardin Hector Malot et le Jardin de Reuilly planté sur un bâtiment de parking avec espaces verts pontés.

El "paseo ajardinado" comienza en un viaducto del ferrocarril (Le Viaduc des Arts) en la Place de la Bastille y se extiende en dirección del Bois de Vincennes hacia las afueras de la ciudad, integrando otras instalaciones de parques, como p. ej. el pequeño Jardin Hector Malot y el Jardin de Reuilly ubicado sobre un parking con una zona verde franqueada.

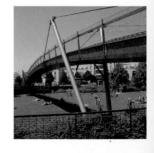

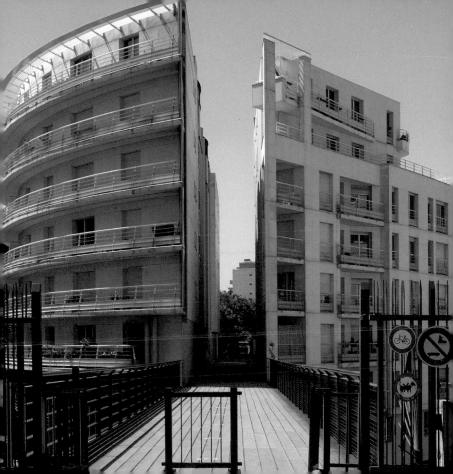

Notre-Dame de l'Arche d'Alliance

Architecture Studio

1998
81, rue d'Alleray
15. Arrondissement

www.ndarche.org
www.architecture-studio.fr

The church cube made of twelve pillars analogous to the twelve apostles stands like a shrine. The baptistery forms the ground floor. A lattice structure surrounding the building that is continued in the interior as an iconostasis—the mural wall of the Byzantine church—opens the hermetic cube to the surroundings.

Wie ein Schrein steht der Würfel der Kirche auf zwölf Säulen, analog der zwölf Apostel. Die Taufkapelle bildet das Erdgeschoss. Eine den Bau umgebende Gitterstruktur, die sich im Inneren als Ikonostase – die Bilderwand der byzantinischen Kirche – fortsetzt, öffnet den hermetischen Kubus zur Umgebung.

Comme un écrin, le cube de l'église repose sur douze piliers, en analogie aux douze apôtres. La chapelle baptismale constitue le rez-de-chaussée. Une structure de grilles entourant la construction qui se poursuit dans l'enceinte comme iconostase – le retable de l'église byzantine – ouvre le cube hermétique à l'environnement.

Como un relicario se encuentra el hexaedro de la iglesia sobre doce columnas, una analogía de los doce apóstoles. La capilla bautismal constituye la planta baja. Una estructura de verjas rodea la construcción. Dicha estructura, que se extiende hacia el interior en un iconostasio, el retable de las iglesias bizantinas, abre el cubo hermético hacia el entorno.

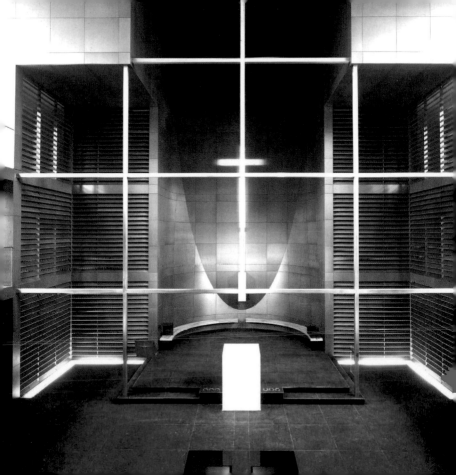

Le Jardin Atlantique
The Atlantic Garden

François Brun
Michel Pena

1994
Place des Cinq-Martyrs-du-Lycée-
Buffon
15. Arrondissement

The Jardin Atlantique is to be found on the roof above the Montparnasse train-station railway system. Along with tennis courts, it includes various types of gardens, despite the cramped space: an architectural garden, a landscaping garden, and even a generous lawn for the densely built quarter.

Der Jardin Atlantique befindet sich auf dem Dach oberhalb der Gleisanlagen des Bahnhofs Montparnasse. Neben Tennisanlagen umfasst er trotz des beengten Raumes verschiedene Gartentypen: einen architektonischen Garten, einen Landschaftsgarten und sogar großzügige Rasenflächen für das dicht bebaute Viertel.

Le Jardin Atlantique se trouve sur le toit au-dessus de l'installation des voies de la gare Montparnasse. Outre des courts de tennis, il comprend différents types de jardins malgré l'espace restreint : des jardins architectoniques, des jardins paysagers et même des surfaces de pelouse généreuse pour le quartier dense en constructions.

El Jardin Atlantique se halla sobre el tejado por encima de las vías de la estación de tren de Montparnasse. Junto a pistas de tenis comprende diferentes tipos de jardín pese a su escasa superficie: un jardín arquitectónico, un jardín paisajístico e incluso amplias zonas de césped para el distrito muy urbanizado.

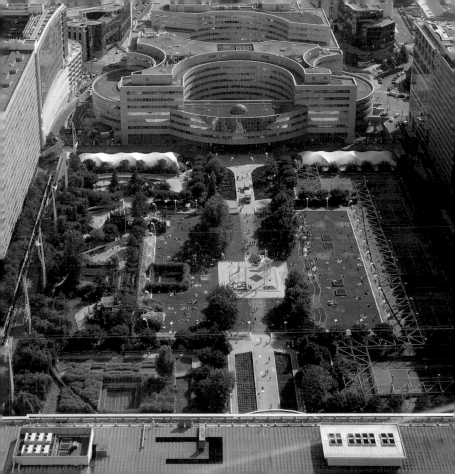

Parc André-Citroën

Gilles Clément, Allain Provost (Landscape)
Patrick Berger, Jean-Paul Viguier,
Jean-François Jodry et Associés (Architecture)

1992
Quai André-Citroën
15. Arrondissement

www.viguier.com

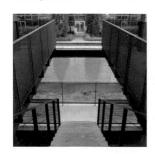

A large meadow, whose flanks have very differing characters, is to be found in the center of the irregular construction on the premises of the former automobile factory. Theme gardens with Mediterranean plants or arranged as rock gardens are found in the north. In the west the Seine, and in the east two large greenhouses formed like temples with architectural fountains in between.

Au centre de l'installation irrégulière sur le site de l'ancienne fabrique automobile se trouve une grande prairie dont les flancs ont un caractère très différent. Au Nord se trouvent les jardins thématiques et leurs plantations exotiques ou leurs rocailles, à l'Ouest la Seine et à l'Est deux grandes serres en forme de temple avec des jeux d'eaux entre les deux constructions.

Im Zentrum der unregelmäßigen Anlage auf dem Gelände der ehemaligen Automobilfabrik befindet sich eine große Wiese, deren Flanken unterschiedlichen Charakter haben. Im Norden befinden sich Themengärten mit südländischer Bepflanzung oder als Steingärten, im Westen die Seine und im Osten zwei große tempelförmige Gewächshäuser mit Wasserspielen dazwischen.

En el centro de esta instalación irregular construida en el terreno de la antigua fábrica de automóviles se halla un amplio prado, cuyos cuatro flancos poseen caracteres muy variados. Al norte se encuentran jardines temáticos con plantas mediterráneas o jardines rocosos al oeste se encuentra el Sena y al este dos grandes invernaderos en forma de templo con juegos de agua intercalados.

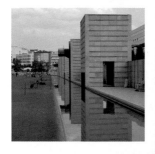

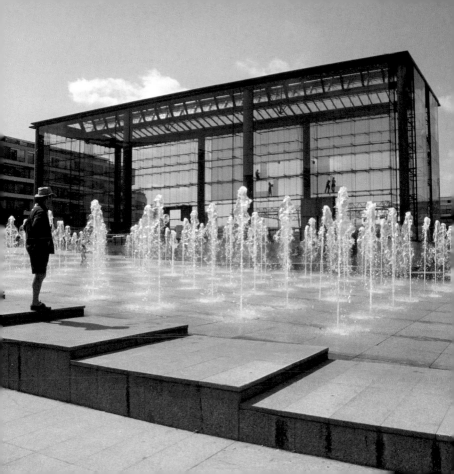

Parc de la Villette

Bernard Tschumi (Park, Extravagance, Galleries)

1992 (Parc de la Villette)
Avenue Jean-Jaurès /
galerie de l'Ourcq
19. Arrondissement

www.tschumi.com

In the industrial north of Paris, the park is a new center and a greenbelt recreational area at the same time. On the edge of the green meadows stand deconstructivistic pavilions made of metal in the complementary color of red. Even though they remind one of follies—staffage architecture of the parks from the 19th century—they have concrete functions.

Im industriellen Norden von Paris ist der Park ein neues Zentrum und zugleich Naherholungsgebiet. Am Rand der grünen Wiesen stehen dekonstruktivistische Pavillons aus Metall in der Komplementärfarbe Rot. Obwohl sie an Follies – Staffagearchitekturen der Parkanlagen des 19. Jahrhunderts – erinnern, haben sie konkrete Funktionen.

Situé au nord industriel de Paris, le parc est un nouveau centre tout en étant une aire de repos de proximité. En bordure des pelouses vertes se trouvent des pavillons déconstructivistes en métal de couleur complémentaire rouge. Bien qu'ils rappellent l'architecture en palier de Follie dans les installations de parcs du 19e siècle, ils ont des fonctions concrètes.

En el industrializado norte de París, este parque es un nuevo centro y zona recreativa periurbana a la vez. Al margen de los verdes prados hay pabellones metálicos de estilo deconstructivista pintados en el color complementario rojo. Aunque recuerdan a los Follies –la arquitectura figurante de los parques del siglo XIX– desempeñan funciones muy concretas.

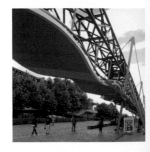

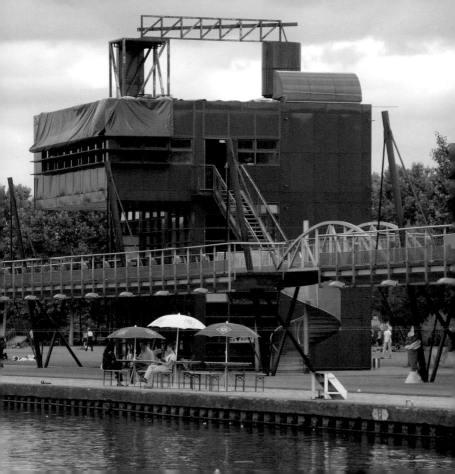

Saint-Luc

Pierre-Henri Montel
Christian Basset

1999
80, rue de l'Ourcq / pass. Watteaux
19. Arrondissement

www.catholique-paris.cef.fr/
paroisses/StLuc.htm

At first glance, the church has an effect like a residential home with a glassed-in staircase. However, the stairs only reach the gallery in the first floor. Only the elegant cross reveals that this is a church. In the interior also, the simplest means serve to lend the high hall a sacred character.

Auf den ersten Blick wirkt die Kirche wie ein Wohnhaus mit verglastem Treppenhaus. Die Treppe reicht jedoch nur bis zur Empore im ersten Obergeschoss. Lediglich das elegante Kreuz zeigt, dass es sich um eine Kirche handelt. Auch im Inneren dienen einfachste Mittel dazu, dem hohen Saal einen sakralen Charakter zu verleihen.

A première vue, l'église donne l'impression d'une maison d'habitation avec cage d'escalier en verre. L'escalier ne monte néanmoins qu'à la galerie au premier étage. Seule l'élégante croix montre qu'il s'agit d'une église. Dans l'enceinte également, les moyens les plus simples servent à conférer à la haute salle un caractère sacré.

A primera vista, la iglesia aparenta ser un edificio de viviendas con unas escaleras de cristal. Sin embargo, las escaleras sólo alcanzan hasta la tribuna en el primer piso. Sólo la elegante cruz revela que se trata realmente de una iglesia. También en su interior se han empleado los medios más sencillos para conferir carácter sacral esta sala de gran altitud.

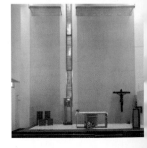

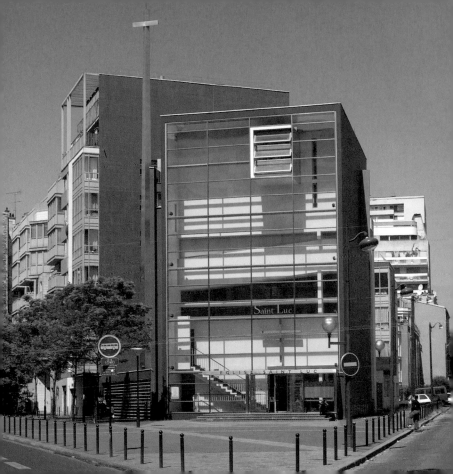

39. **Lentille Météor St.-Lazare**
arte-charpentier et associés,
Abbès Tahir

2003

8. Arrondissement

Rénovation du Métro
et Ligne Météor

One century after the construction of the first Métro stations by Héctor Guimard, the city obtained numerous new stations. What they have in common is that they are all very different: technology-emphasized with videos, or postmodernist with sandstone facings, pillars, and coffered ceilings.

Ein Jahrhundert nach dem Bau der ersten Métro-Stationen von Héctor Guimard hat die Stadt zahlreiche neue Stationen erhalten. Gleich ist ihnen, dass sie alle sehr unterschiedlich sind: technikbetont mit Videos oder postmodern mit Sandsteinverkleidung, Säulen und Kasettendecken.

Un siècle après la construction des premières stations de Métro par Héctor Guimard, la ville a été dotée de nombreuses nouvelles stations. Leur point commun c'est qu'elles sont toutes très différentes : Tantôt elles mettent l'accent sur la technique avec des vidéos, ou encore postmodernes aux parements en grès, aux colonnes et aux plafonds à caissons.

Un siglo después de la construcción de las primeras estaciones de metro por Héctor Guimard, la ciudad ha obtenido numerosas estaciones nuevas. Su denominador común es su diversidad: unas paradas, otras equipadas con vídeos y de estilo preferentemente técnico o al estilo postmodernista con acabados de piedra arenisca, columnas y techos artesonados.

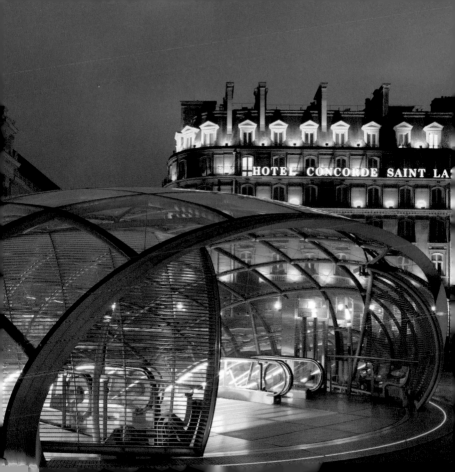

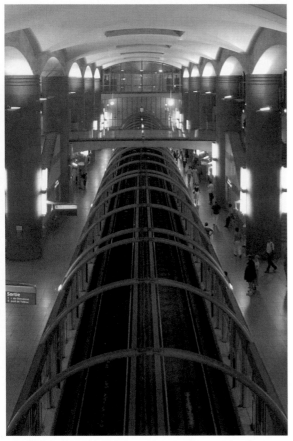

40. **Bibliothèque nationale de France**
Antoine Grumbach, Pierre Schall

2000

13. Arrondissement

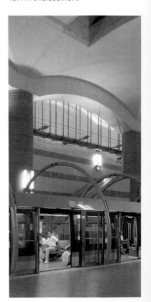

41. **Kiosque de Noctambules**
Jean-Michel Othoniel

2000

1. Arrondissement

Aéroport
Charles de Gaulle Roissy-2

Terminaux 2C, 2F et 2E / Gare RER et TGV
Airport terminals 2C, 2F and 2E / RER and TGV Railway stations

Paul Andreu
Agence des gares SNCF, Jean-Marie Duthilleul, Etienne Tricaud

1993 (Terminal 2C)
1998 (Terminal 2F and Railway station)
2003 (Terminal 2E)
Roissy

www.paul-andreu.com
www.adp.fr
www.arep.fr

Andreu has been expanding the largest Paris airport since 1967. The form of a circle and the travelers ascending toward light are his consistent themes. From the terminals the traveler reaches the glazed departure area. The expanse of the heavens awaiting him is visualized in both zones through the column-free roofing of the large spaces.

Depuis 1967, Andreu procède à l'extension du plus grand aéroport parisien. La forme du cercle et la montée des voyageurs vers la lumière constituent ses motifs constants. A partir des halles de contrôle le voyageur accède aux secteurs d'envol en verre. L'étendue du ciel qui l'attend maintenant est visualisée dans les deux zones par la toiture sans appui des grandes salles.

Seit 1967 erweitert Andreu den größten Pariser Flughafen. Die Form des Kreises und das Aufsteigen des Reisenden zum Licht sind seine konstanten Motive. Aus den Abfertigungshallen gelangt der Reisende in die gläsernen Abflugbereiche. Die Weite des Himmels, die ihn nun erwartet, wird in beiden Zonen durch eine stützenfreie Überdachung der großen Räume visualisiert.

Desde 1967, Andreu ha venido ampliando el aeropuerto más grande de París. La forma circular y el detalle de que los viajeros ascienden hacia la luz son sus motivos constantes. Desde las salas de facturación los viajeros pasan a las zonas acristaladas de salida. La infinitud del cielo al que se elevarán en breve es visualizada en ambas zonas mediante techos sin pilares.

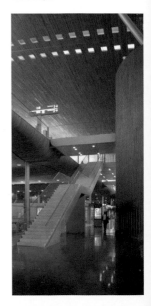

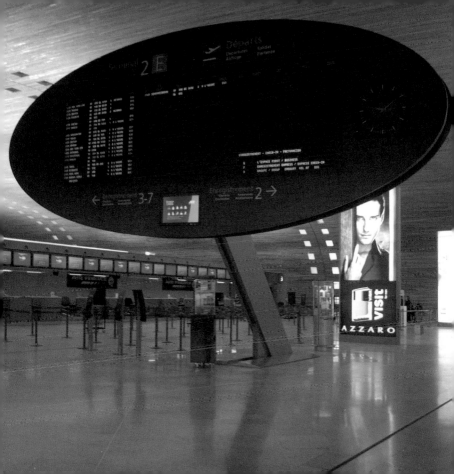

Notre-Dame-
de-la-Pentecôte

Franck Hammoutène

1997
Parvis de la Défense
La Défense

www.catholiques.aladefense.ce.fr

The church seems to be a miniature version of the office highrises surrounding it. But, it is exactly these modest dimensions that let it appear to be more precious. Through a low ground floor, one climbs up to the main room in which the translucent altar wall simultaneously lights and hides the surroundings.

Die Kirche wirkt wie eine Miniaturversion der sie umgebenden Bürohochhäuser, doch gerade die bescheidenen Ausmaße lassen sie kostbarer erscheinen. Durch ein niedriges Erdgeschoss steigt man in den Hauptraum auf, dessen transluzente Altarwand gleichzeitig belichtet und die Umgebung ausblendet.

L'église fait l'effet d'une version miniature des immeubles de bureaux qui l'entourent, et ce sont pourtant justement les dimensions humbles qui lui donnent une apparence plus précieuse. Via un rez-de-chaussée à plafond bas, on accède à la salle principale, dont le mur d'autel translucide illumine et masque l'environnement.

La iglesia parece una versión en miniatura de los rascacielos de oficinas que la circundan, pero precisamente sus humildes dimensiones le confieren un aspecto más valioso. A través de la planta baja de poca altura se asciende hacia la sala principal, cuya pared del altar es translúcida, dando luz y dejando simultáneamente en la penumbra el entorno.

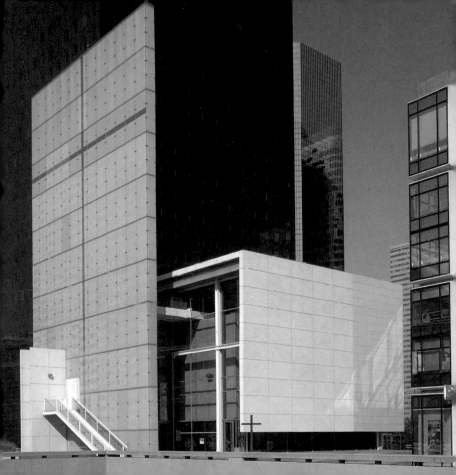

Cathédrale de la Résurrection

Mario Botta

1995
Cour Monseigneur Romero /
place des Droits de l'Homme et du
Citoyen
Evry, Corbeil-Essonne

www.catholique-evry.cet.fr/
cathedrale
www.botta.ch

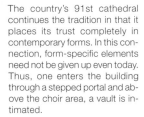

The country's 91st cathedral continues the tradition in that it places its trust completely in contemporary forms. In this connection, form-specific elements need not be given up even today. Thus, one enters the building through a stepped portal and above the choir area, a vault is intimated.

Die 91. Kathedrale des Landes knüpft an die Tradition an, indem sie ganz und gar auf zeitgenössische Formen setzt. Hierbei brauchen auch heute gattungsspezifische Elemente keineswegs aufgegeben werden. So betritt man den Bau durch ein Stufenportal und oberhalb des Chorbereichs wird ein Gewölbe angedeutet.

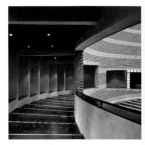

La 91e cathédrale du pays renoue avec la tradition en s'appuyant intégralement sur les formes contemporaines. Dans le cas présent, aucun élément spécifique au genre n'a dû être abandonné, même aujourd'hui. On pénètre ainsi dans la construction par un parvis à paliers et une voûte est ébauchée au-dessus du chœur.

La 91ª catedral del país retoma la tradición al pujar por las formas contemporáneas. Tampoco hoy en día es necesario prescindir de los elementos típicos del estilo gótico, y así uno entra en la iglesia a través de un portal con escalones, y por encima de la zona del coro se ha insinuado una bóveda.

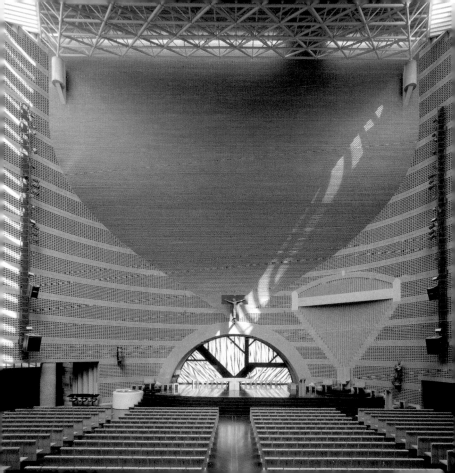

to stay . hotels

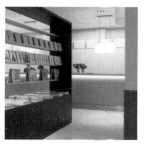

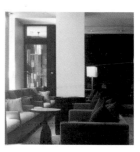
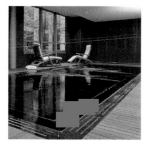
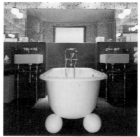

105

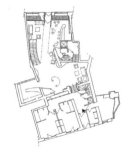

Artus Hôtel

Alain Perrier (Interior Design)

1992
34, rue de Buci
6. Arrondissement

www.artushotel.com

The hotel draws its charm from the varied design in warm shades and the winding layout of the individual rooms in the residential building from the 18th century. The impression that this is not a hotel but rather an expensive private accommodation is continued in the rooms and their individual, artist-designed doors.

L'hôtel tire son charme de l'aménagement varié en tons chaleureux et de la disposition tortueuse des pièces individuelles dans le bâtiment d'habitation du 18e siècle. L'impression selon laquelle il ne s'agit pas d'un hôtel mais d'un hébergement privé de haut niveau se poursuit dans les chambres et leurs portes décorées de manière individuelle par des artistes.

Das Hotel bezieht seinen Charme aus der vielfältigen Gestaltung in warmen Tönen und der verwinkelten Anordnung der einzelnen Räume in dem Wohngebäude des 18. Jahrhunderts. Der Eindruck, es handele sich nicht um ein Hotel, sondern um eine gehobene Privatunterkunft, setzt sich in den Zimmern und deren individuell von Künstlern gestalteten Türen fort.

El encanto de este hotel reside en su variada decoración en tonos cálidos y en la disposición angular de las diferentes salas en el edificio de viviendas del siglo XVIII. La impresión de que no se trata de un hotel, sino de un alojamiento privado de alta calidad se repite en las habitaciones con sus puertas decoradas de forma individual por diferentes artistas.

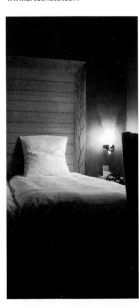

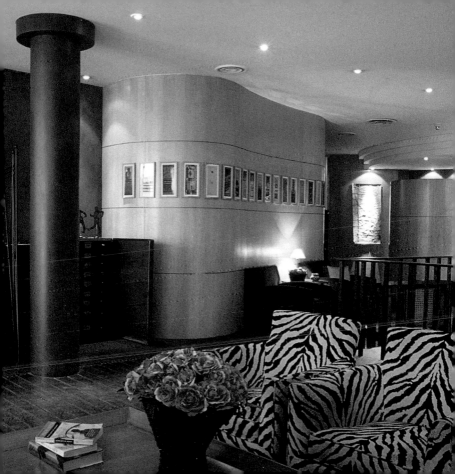

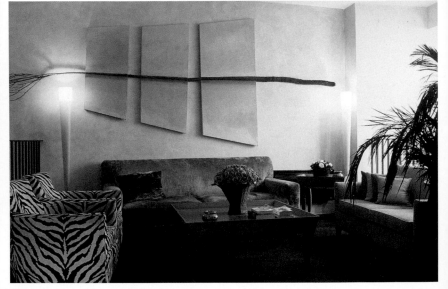

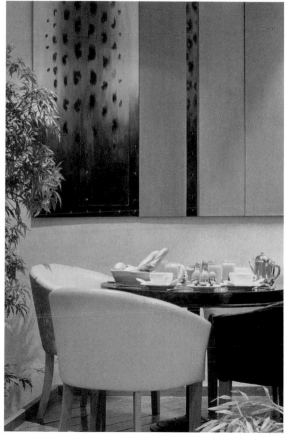

Bel-Ami

Grace Leo-Andrieu, Michel Jouannet (Interior design, 3rd-6th Floor)
Nathalie Battesti, Veronique Terreaux (Interior design, 1st-2nd Floor)

2003 (Interior design, 3rd-6th Floor)
2000 (Interior design, 1st-2nd Floor)
7-11, rue Saint-Benoît
6. Arrondissement

www.hotel-bel-ami.com
www.glainternational.fr
www.ideogalerie.com

The architecture and interior are characterized by clear forms and functional orderliness on the one hand as well as by warm natural materials on the other. Through this, the bright public areas have a cosy and simultaneously timelessly modern effect. Hotel functionality and a feeling of being home are combined in the rooms also.

Architektur und Interieur werden von klaren Formen und sachlicher Ordnung einerseits sowie von warmen Naturmaterialien andererseits geprägt. So wirken die hellen öffentlichen Bereiche zugleich gemütlich und zeitlos modern. Auch in den Zimmern verbinden sich Hotelsachlichkeit und ein Gefühl von zu Hause.

L'architecture et l'intérieur sont marqués par des formes claires et un ordre rationnel d'une part ainsi que de matériaux naturels chaleureux d'autre part. Les pièces publiques claires font ainsi un effet confortable et intemporellement moderne. Dans les chambres également se combinent l'esprit rationnel de l'hôtel et un sentiment d'être chez soi.

El estilo arquitectónico y el interior se caracterizan por sus formas claras y su orden objetivo y, además, por la calidez que emana de los materiales naturales utilizados. Las luminosas zonas públicas poseen un aire acogedor, a la vez que un toque moderno de carácter intemporal. También las habitaciones aúnan el estilo neutral de un hotel y el confort del hogar.

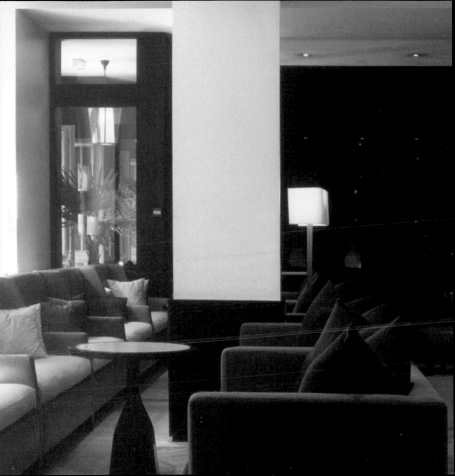

Hôtel de la Trémoille

Richard Marinet (Hotel)
Terence Conran (Restaurant, Bar)

2002
14, rue de la Trémollle
8. Arrondissement

www.hotel-tremoille.com

The aim of the total renovation of the hotel was to adapt modern comfort into historical ambience. Restored stuccowork and fireplace mantles create the starting point for the compilation of the furniture in traditional basic forms.

Modernen Komfort in ein historisches Ambiente einzupassen war das Ziel der Runderneuerung des Hotels. Restaurierte Stuckaturen oder Kaminverkleidungen bilden den Ausgangspunkt für die Zusammenstellung der Möbel in traditionellen Grundformen.

Insérer un confort moderne dans une ambiance historique était l'objectif de la restauration complète de l'hôtel. Les stucs et corps de cheminée constituent le point de départ à la composition du mobilier dans des formes fondamentales traditionnelles.

El objetivo de la renovación completa del hotel fue crear un ambiente cómodo moderno en un entorno histórico. Los estucados restaurados y los revestimientos de las chimeneas fueron el punto de partida a la hora de elegir el mobiliario de formas básicas tradicionales.

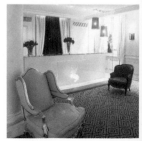

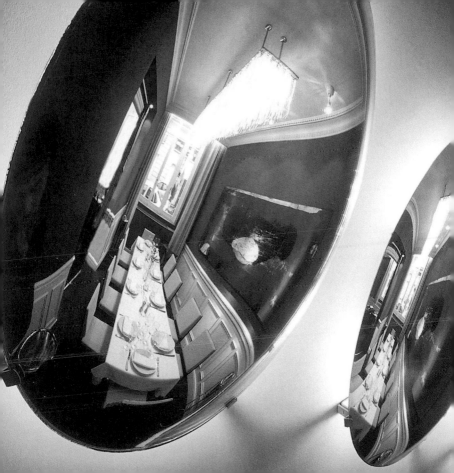

Pershing Hall

Canal, Andrée Putman (Interior design)

2001
49, rue Pierre-Charron
8. Arrondissement

www.pershing-hall.com
www.andreeputman.com

The old building from the second empire supplied the frame of the design with its magnificent staircase and an inner courtyard. The main theme for the redesigning is spheres that integrate themselves in the neo-empire as classicistic basic elements.

Der Altbau des zweiten Kaiserreichs gab mit großartigen Treppenaufgängen und einem Innenhof den Rahmen für die Gestaltung vor. Hauptmotiv der Neugestaltung sind Kugeln, die sich als klassizistisches Grundelement hervorragend in das Neoempire eingliedern.

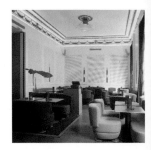

La construction ancienne du deuxième empire a déterminé le cadre de l'aménagement par des escaliers somptueux et une cour intérieure. Le motif principal de l'aménagement intérieur est constitué par des globes qui s'intègrent de manière excellente comme élément de base classique dans le néoclassicisme.

El edificio antiguo de la época del Segundo Imperio ofreció, con sus espléndidas escaleras y su patio interior, el marco para la decoración del mismo. El motivo principal de su nuevo diseño son bolas que como elemento básico de estilo clasicista se integran perfectamente en el estilo neoimperial.

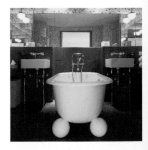

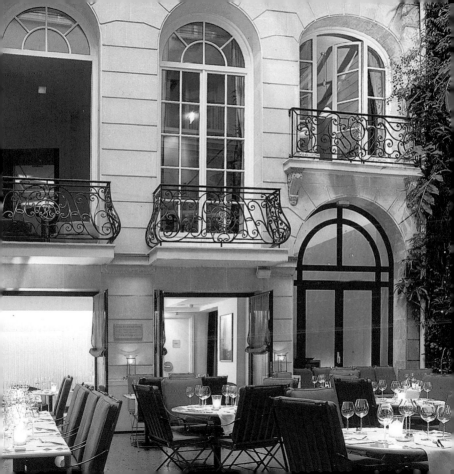

Hôtel Costes K

Ricardo Bofill - Tallo de Arquitectura
Fabrice Hybert (Interior design)

1993
81, avenue Kléber
16. Arrondissement

www.bofill.com

The architecture of the hotel, which is situated around an inner courtyard, is characterized by strict right-angled forms. Cubes made out of marble, glass, and steel form the frame for a form-reduced interior in which warmer materials and discrete colors lend the bright rooms a semblance of ease.

Die Architektur des um einen Innenhof gelegenen Hotels ist von streng rechtwinkligen Formen geprägt. Kuben aus Marmor, Glas und Stahl bilden den Rahmen für ein formreduziertes Inneres, in dem wärmere Materialien und dezente Farben den hellen Räumen Leichtigkeit verleihen.

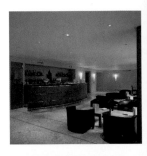

L'architecture de l'hôtel situé autour d'une cour intérieure est marquée par des formes austères à angle droit. Des cubes en marbre, en verre et en acier constituent le cadre pour un intérieur à forme réduite dans lequel ont été ajoutés des matériaux plus chaleureux et des couleurs décentes conférant aux pièces claires un effet de légèreté.

La arquitectura del hotel que se despliega alrededor de un patio interior está caracterizada por formas mantenidas estrictamente en ángulo recto. Cubos de mármol, vidrio y acero forman el marco exterior del espacio interior de formas reducidas, al que se han añadido materiales más cálidos y colores discretos para conferir a las salas una singular ligereza.

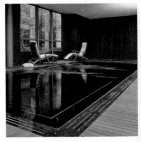

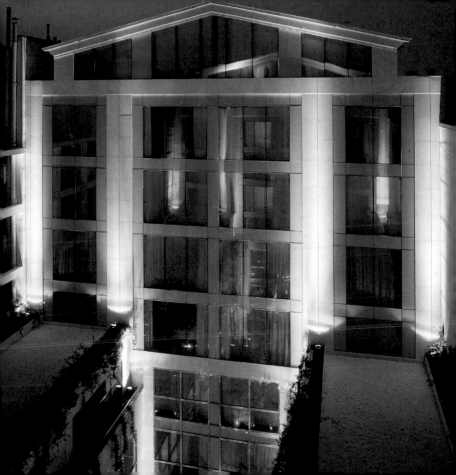

to go . eating
drinking
clubbing
wellness, beauty & sport
leisure

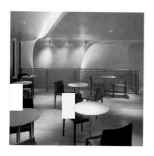 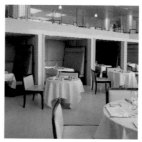 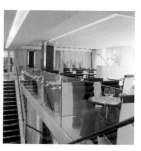

 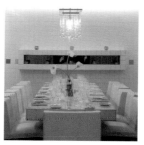 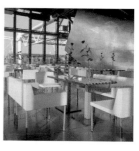

 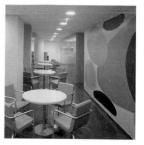

Étienne Marcel

M/M Paris, Pierre Huyghe, Philippe Parreno (Design)

2002
34, rue Étienne-Marcel
2. Arrondissement

www.mmparis.com

The ambivalence of the 1960's, pop-public against cuddle utopia, is used here as the concept of the café. On the one hand, the "booth-buckets" by the synthetic design classic; on the other, the open space and the connecting lighting.

Die Ambivalenz der 1960er Jahre, Pop-Öffentlichkeit gegen Kuschel-Utopie, wird hier zum Konzept des Cafés. Einerseits die „Separée-Mulden" der Kunststoff-Designklassiker, andererseits der offene Raum und die verbindende Beleuchtung.

L'ambivalence des années 1960 et la scène publique pop contre l'utopie de la tendresse sont ici le concept du café. D'une part la « cavité séparée » du classique de design plastique, d'autre part la pièce ouverte et l'éclairage unissant.

La ambivalencia de los años 60 del siglo pasado –el pop en la vida pública frente a la utopía del estilo ultracómodo– se convierte aquí precisamente en el concepto del café. Por una parte nos encontramos con los compartimentos separados con los muebles de plástico de los clásicos del diseño y, por otra, el espacio abierto y la iluminación que los unifica.

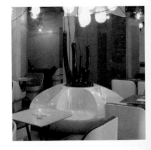

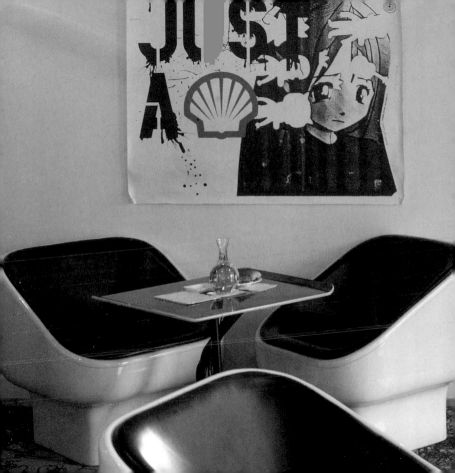

Andy Wahloo

Hassan Hajjaj

2003
69, rue des Gravilliers
3. Arrondissement

The "Andy Wahloo", the Arabian "I have nothing", shows how a widely varied design can be made from a small budget. Paint cans with colorful pillows serve as stools and signs as tabletops, Moroccan packaging as decoration, colorfully filled bottles as light filters.

Das „Andy Wahloo", das arabische „Ich habe nichts", zeigt, wie aus einem schmalen Budget eine vielfältige Gestaltung wird. Lackeimer mit bunten Kissen dienen als Hocker und Schilder als Tischplatten, marokkanische Verpackungen als Dekoration, farbig gefüllte Flaschen als Lichtfilter.

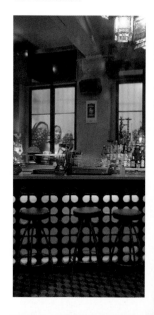

L' « Andy Wahloo », le « Je n'ai rien » arabe montre comment il est possible d'obtenir un aménagement varié à partir d'un budget restreint. Des seaux laqués avec des coussins multicolores servent de tabourets et des panneaux de plateaux de tables, des emballages marocains de décoration et des bouteilles colorées de filtres à lumière.

El "Andy Wahloo", que en árabe significa "No tengo nada", es un ejemplo de cómo se logra una decoración variopinta con un presupuesto reducido. Cubos de pintura con cojines de colores sirven como baburetes, carteles como tableros de mesas, embalajes marroquís como decoración, y botellas de contenido coloreado como filtros de luz.

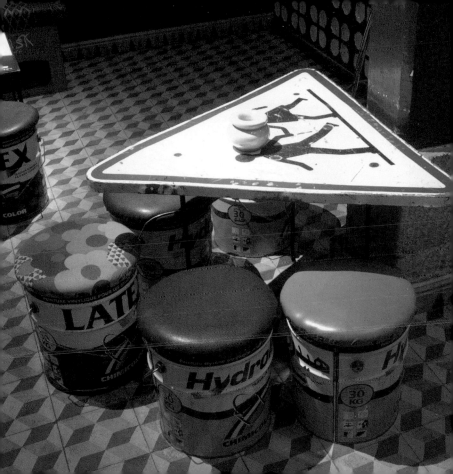

Georges

Dominique Jakob + Brendan
Macfarlane (Architecture)

2000
19, rue Beaubourg
4. Arrondissement

www.centrepompidou.fr
www.cnag-gp.fr

Amorphous spatial forms characterize the restaurant in Centre Pompidou. The voluminous large formats not only split up the large hall but with their thin and hard steel skin also create a distinct contrast to the tightly organized, technology-accented architecture of the center (see no. 16).

Amorphe Raumformen prägen das Restaurant im Centre Pompidou. Die voluminösen Großformen teilen den großen Saal nicht nur auf, sondern bilden mit ihrer dünnen und harten Haut aus Stahl auch einen deutlichen Kontrast zur straff organisierten, technikbetonten Architektur des Zentrums (siehe Nr. 16).

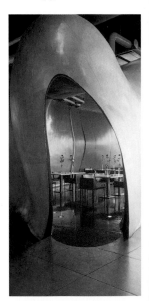

Des formes de pièces amorphes marquent le restaurant dans le Centre Pompidou. Les grandes formes volumineuses ne font pas que partager la grande salle, mais avec leur peau fine et dure en acier, elles constituent un contraste distinct par rapport à l'architecture d'organisation rigide du centre mettant l'accent sur la technique (voir n° 16).

Las formas amorfas del espacio interior caracterizan el restaurante del Centro Pompidou. Las voluminosas formas por una parte dividen la gran sala y por otra representan, con su fina y dura estructura de acero, un claro contraste frente a la arquitectura organizada hasta en los más mínimos detalles y de carácter claramente técnico (véase el n° 16).

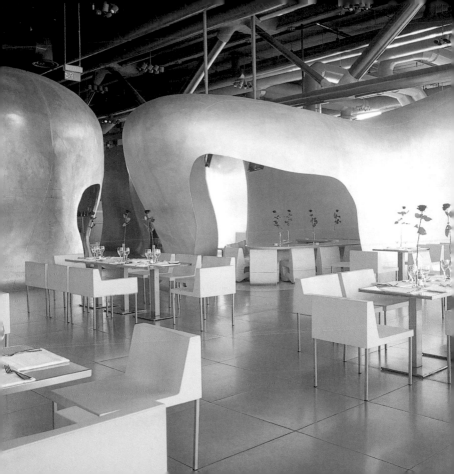

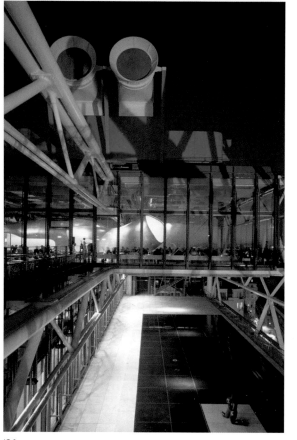

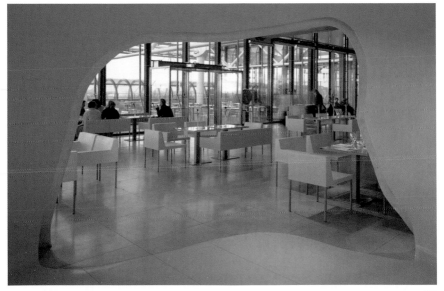

Joe's Café à Joseph

Christian Biecher

2001
277, rue Saint-Honoré
8. Arrondissement

www.biecher.com

The restaurant is distinguished by an unobtrusive modern design. Installations and lighting effects subdivide the rooms. The specially designed salesrooms and restaurant furnishings have an easing effect in which the design elements clearly emerge.

Eine unaufdringliche moderne Gestaltung kennzeichnet das Restaurant. Einbauten und Beleuchtungseffekte gliedern die Räume. Entsprechend leicht wirkt das eigens entworfene Mobiliar der Verkaufsräume und des Restaurants, bei dem die Gestaltungselemente deutlicher in Erscheinung treten.

Un aménagement moderne et discret caractérise le restaurant. Des objets encastrés et des effets d'éclairage partagent les pièces. C'est un effet de légèreté correspondant que donne le mobilier conçu personnellement pour les locaux de vente et le restaurant, dans lequel les éléments d'aménagement font leur apparition de manière plus distincte.

El restaurante destaca por su agradable decoración interior en estilo moderno. Las salas son divididas ópticamente por módulos y efectos luminosos. El mobiliario del restaurante y de la sala de venta diseñados al efecto proporcionan igualmente un toque de ligereza resaltando así los elementos decorativos.

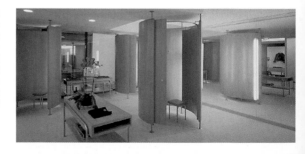

La Cantine du Faubourg

Pira (Interior design)
Axel Schoenert, cabinet ROOM (Architecture)

2001
105, rue du Faubourg-Saint-Honoré
8. Arrondissement

www.lacantine.com
www.pirasculpteur.com

The "canteen" for 500 persons can function as a restaurant, lounge, or club. For concerts and other events, enormous lighting machinery is available that can also bathe the restaurant operation in various lighting atmospheres. Thanks to the projection, the wall decoration is also versatile.

Die „Kantine" für 500 Personen kann als Restaurant, Lounge und Club fungieren. Für Konzerte und andere Events steht eine enorme Lichtmaschinerie zur Verfügung, die auch den Restaurantbetrieb in verschiedene Lichtstimmungen tauchen kann. Auch das Wanddekor ist dank der Projektion wandlungsfähig.

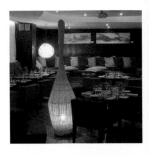

La « cantine » pour 500 personnes peut se convertir en restaurant, en lounge et en club. Pour les concerts et les autres évènements est mise une énorme machinerie de lumières à disposition qui peut immerger également le restaurant dans diverses ambiances lumineuses. La décoration murale est également modulable grâce à la projection.

La "Cantina" en la que tienen cabida 500 personas puede utilizarse como restaurante, lounge y club. Dispone de una enorme instalación de iluminación para conciertos y otros acontecimientos, capaz de sumergir el restaurante en diferentes ambientes lumínicos. Con ayuda de la proyección de luz también puede variarse el decorado de las paredes.

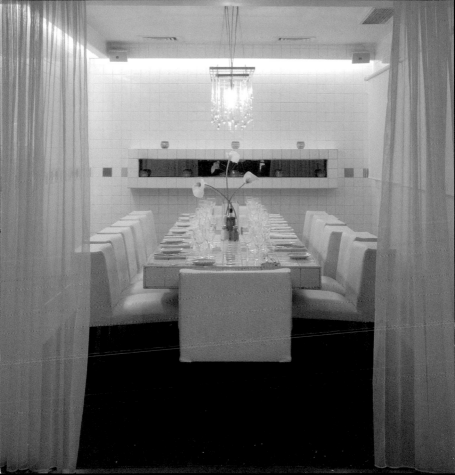

La Maison Blanche

Imaad Rahmouni (Restructured)
Frank Hammoutène (Architecture)
Henry van de Velde, Roger Bovard, Auguste Perret
(Théâtre des Champs-Élysées)

2000
1913 (Theater)
15, avenue Montaigne
8. Arrondissement

www.maison-blanche.fr
www.theatrechampselysees.fr
www.imaadrahmouni.com

Situated in the receding raise of the Théâtre des Champs-Élysées, the restaurant covering two floors offers a view over the city to Montmartre and the Eiffel Tower. The interior decoration in light, refracted beige and with a palette of pastel colored lights brings soft color into the whiteness of the building.

Gelegen in der zurücktretenden Aufstockung des Théâtre des Champs-Élysées, bietet das über zwei Etagen gehende Restaurant einen Ausblick über die Stadt zum Montmartre und Eiffelturm. Die Innenraumgestaltung in hellem, gebrochenem Beige und mit einer Palette pastellfarbiger Lichter bringt dezent Farbe in das Weiß des Hauses.

Situé sur la surélévation en arrière du Théâtre des Champs-Élysées, le restaurant sur deux étages offre une vue via la ville sur Montmartre et la tour Eiffel. L'aménagement intérieur en beige clair, cassé et avec une palette de lumières de couleurs pastelles apporte de la couleur de manière décente dans le blanc de la maison.

Situado en el nuevo piso algo desplazado hacia atrás del Théâtre des Champs-Élysées, este restaurante de dos pisos ofrece una vista sobre la ciudad en dirección al Montmartre y a la Torre Eiffel. El diseño del interior mantenido en un tono beige claro quebrado y la iluminación con una gama de luces de color pastel confieren una discreta nota de color al tono blanco de la casa.

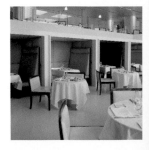

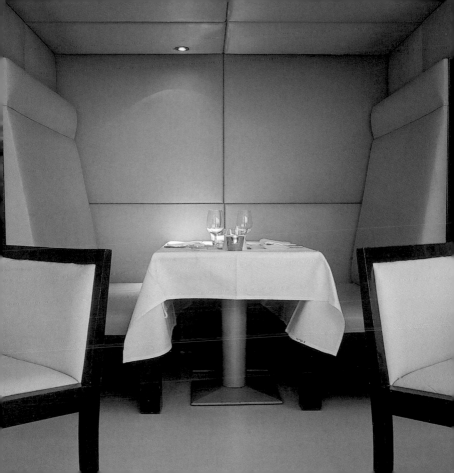

La Suite

Imaad Rahmouni

2001
40, avenue Georges V
8. Arrondissement

www.imaadrahmouni.com

Horizontal leather upholsteries are the central theme of the furnishings and they cover all chairs, benches, and stools. Kept in white and dark-brown, they don't only give the bright "deluxe suite" a distinctiveness, but also calm the colorfully lighted zones.

Horizontale lederne Polster sind das Hauptmotiv der Einrichtung und sie überziehen sämtliche Stühle, Bänke und Hocker. In Weiß und Dunkelbraun gehalten, geben sie nicht nur der hellen „de Luxe Suite" Distinguiertheit, sondern beruhigen auch die farbig beleuchteten Zonen.

Des rembourrages en cuir horizontaux constituent le motif principal de l'aménagement et recouvrent l'ensemble des chaises, bancs et tabourets d'un bombage doux. Gardés en blanc et en marron foncé, ils ne confèrent pas seulement un aspect distingué à la suite de luxe claire, ils apaisent aussi les zones éclairées en couleur.

La tapicería horizontal de cuero, con la que están revestidas todas las sillas, los bancos y los taburetes es el motivo principal de la decoración interior. Mantenida en los tonos blanco y marrón oscuro, le confieren distinción no sólo a la luminosa "Suite de Luxe", sino que también dan un aire más tranquilo a las zonas iluminadas en diferentes colores.

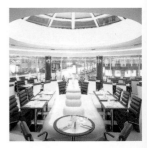

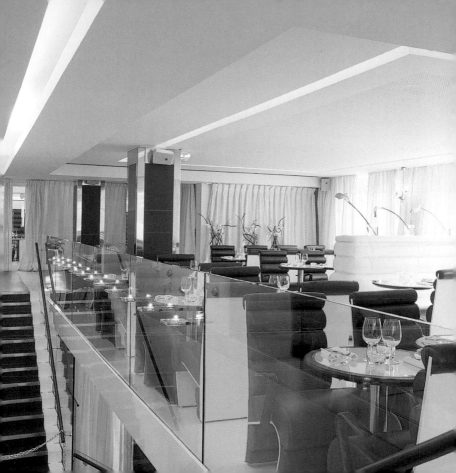

Lô Sushi

Andrée Putman

1999
8, rue de Berri
8. Arrondissement

www.losushi.com
www.andreeputman.com

Putman optimally utilized the small accommodation behind the Champs-Élysées. The dining ribbon follows the L-shaped base position of the room. The formal reduction of the furnishings, the subdued colors, and a large mirror let the cramped room appear to be generous.

Die kleine Räumlichkeit hinter den Champs-Élysées hat Putman optimal genutzt. Das Essensband folgt der L-förmigen Grunddisposition des Raumes. Die formale Reduktion der Einrichtung, die gedeckten Farben und ein großer Spiegel lassen den beengten Raum großzügig erscheinen.

Putman a utilisé le petit local derrière les Champs-Élysées de manière optimale. La bande de repas suit la disposition de base en forme de L de la pièce. La réduction formelle de l'équipement, les couleurs tamisées et un grand miroir confèrent une impression généreuse à l'espace restreint.

Putman ha aprovechado óptimamente el espacio interior de este pequeño local detrás de los Campos Elíseos. La cinta sobre la que se transportan los platos discurre en forma de L siguiendo la forma básica del establecimiento. La reducción formal de la decoración, los colores apagados y un gran espejo amplían ópticamente el espacio interior.

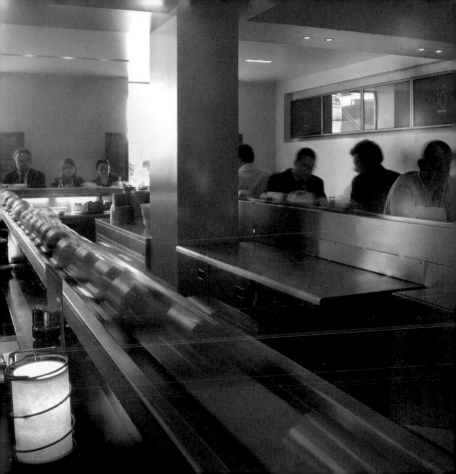

Les Grandes Marches

Elizabeth de Portzamparc

2000
6, place de la Bastille
12. Arrondissement

www.lesgrandesmarches.com
www.elizabethdeportzamparc.com

Even just the different kinds of seats in the restaurant near the new opera forms sections of very differing characters. Common to the chairs are the asymmetrical backs while the type of chair and especially the respective material reflects the different situations from "dining" to "lounging".

Allein schon die verschiedenartige Bestuhlung des Restaurants bei der Neuen Oper bildet Bereiche sehr unterschiedlichen Charakters aus. Gemeinsam ist den Stühlen der asymmetrische Rücken, während der Stuhltyp und insbesondere das jeweilige Material die unterschiedlichen Situationen von „Tafeln" bis „Loungen" kennzeichnet.

Ce sont seulement déjà les chaises de différents types du restaurant situé près du nouvel opéra qui constituent des zones à caractères très divers. Les chaises ont en commun leur dossier asymétrique, alors que le type de chaise et notamment le matériau respectif indiquent les situations diverses de la « table » au « lounge ».

Solamente la variada disposición de las sillas del restaurante en la Nueva Ópera ya conforma áreas de carácter muy distinto. Las sillas tienen en común el respaldo asimétrico, mientras que el tipo de silla y sobre todo el respectivo material caracterizan las diferentes situaciones, desde el "banquetear" hasta la estancia en el lounge.

Café Nescafé

Michele Saee

2002
15, avenue de Wagram
17. Arrondissement

www.nescafe.tm.fr
www.michelesaee.com

The interior is based on a form conception that includes both floors and that stretches to the forebuilding. The glass forebuilding is conceived as a symbol of the brand; flowing ribbons pass through the rooms of the old building, reformulate them, and integrate the seating.

Das Interieur beruht auf einer Formkonzeption, die beide Geschosse umfasst und sich bis in den Vorbau erstreckt. Der gläserne Vorbau ist als Kennzeichen der Marke gedacht; fließende Bänder durchziehen die Räume des Altbaus, formulieren sie neu und integrieren Sitzgelegenheiten.

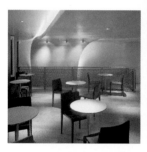

L'intérieur repose sur une conception de forme qui englobe les deux étages et s'étend jusque dans la construction préliminaire. La construction préliminaire en verre a été pensée comme symbole de la marque; des rubans coulants traversent les pièces de la construction ancienne, lui confèrent une nouvelle formulation tout en intégrant des sièges.

El interior está basado en un diseño de forma que engloba ambos pisos y que se extiende hasta el voladizo. Este voladizo de cristal se ha concebido como rasgo distintivo de la marca; bandas difusas entrecruzan los diferentes recintos del edificio antiguo, definiéndolos de una nueva forma e integrando los diversos asientos.

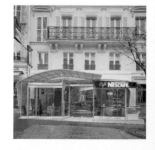

140

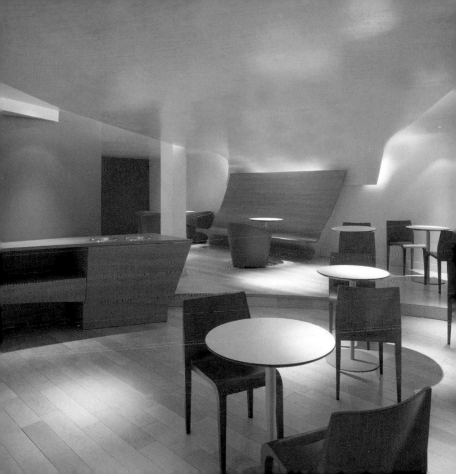

Shiseido la Beauté

A + A Cooren

2002
3-5, boulevard Malesherbes
8. Arrondissement

www.shiseido.co.jp/e/e9608res/
html/index.htm
www.aplusacooren.com

The European Shiseido flagship store consists of a "Cosmetic Lounge" in which the products are presented and applied, and the "Studio", a gallery in which the brand image is further developed through associating exhibitions. White walls, mirrors and light furniture create a gleaming, light atmosphere.

Le Flagship-Store européen de Shiseido est constitué d'un « Cosmetic-Lounge », dans lequel sont présentés et appliqués les produits et du « Studio », une galerie, dans laquelle est poursuivi le développement de l'image de la marque par des expositions en association. Des murs blancs, des miroirs et un mobilier léger créent une atmosphère scintillante et légère.

Der europäische Flagship-Store von Shiseido besteht aus einer „Cosmetic-Lounge", in der die Produkte vorgestellt und angewandt werden, und dem „Studio", einer Galerie, in der das Image der Marke durch assoziierende Ausstellungen weiterentwickelt wird. Weiße Wände, Spiegel und leichte Möbel schaffen eine schimmernde, leichte Atmosphäre.

El flagship-store europeo de Shiseido consta de un "cosmetic-lounge" en el que se presentan y aplican los productos y el "studio", una galería en la que se desarrolla la imagen de la marca mediante exposiciones asociadas a ella. Las paredes blancas, los espejos y los muebles ligeros crean una atmósfera ligera, de luz tenue.

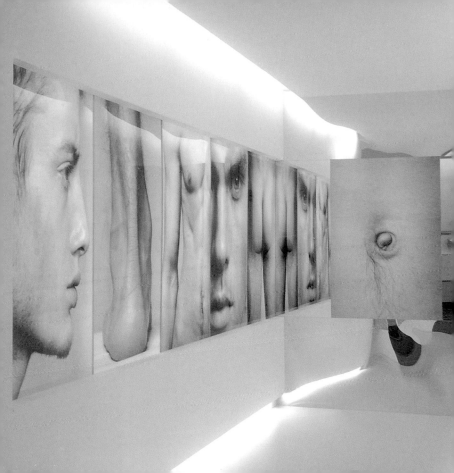

UGC Cine Cité

Denis Valode & Jean Pistre, Alberto Cattani

1998
114, quai de Bercy /
2-8, rue François-Truffaut
12. Arrondissement

www.ugc.fr
www.valode-et-pistre.com

The position of the projection rooms in the multiplex cinema can be distinctly read on the building exterior. They are rigid forms in the otherwise transparent building made of glass and grids through which the Cours Saint-Emilion is extended as a passage to the Seine.

Die Lage der Vorführsäle in dem Multiplex-Kino ist deutlich am Außenbau abzulesen. Sie sind feste Formen in dem sonst durchsichtigen Bau aus Glas und Gittern, durch den sich der Cours Saint-Emilion als Passage zur Seine verlängert.

La situation des salles de projection dans le cinéma multiplex est reconnaissable distinctement sur la construction extérieure. Ce sont des formes fixes dans le bâtiment sinon transparent en verre et en acier grâce auquel le Cours Saint-Émilion se prolonge comme passage jusqu'à la Seine.

La situación de las salas de proyección en el cine multisalas se nota claramente en la construcción exterior. Son formas fijas en el edificio por lo demás transparente, hecho de vidrio y rejas y por el cual se prolonga el Cours Saint-Emilion hacia el Sena como un pasaje.

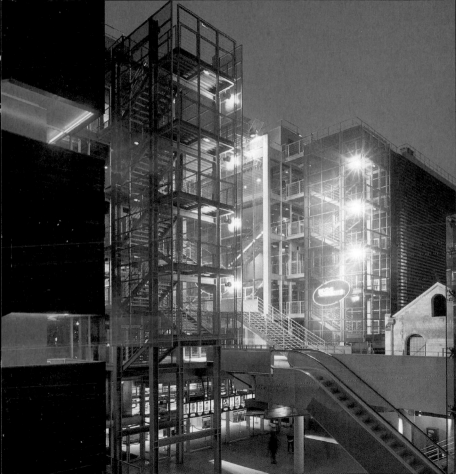

MK2 Bibliothèque

Jean Michel Wilmotte, Frédéric Namur

2003
128/162, avenue de France
13. Arrondissement

www.mk2.com

The complex of the producer Martin Karmitz functions, as a new center of the 130 hectare-comprising "ZAC Rive Gauche". The building accommodates not only 14 cinemas but also three restaurants in different price classes, a bar, exhibition space, and DVD and CD stores, which thread along the passage in the glassed-in ground floor.

Der Komplex des Produzenten Martin Karmitz fungiert, als neues Zentrum des 130 Hektar umfassenden „ZAC Rive Gauche". Das Gebäude beherbergt nicht nur 14 Kinos, sondern auch drei Restaurants verschiedener Preisklassen, eine Bar, Ausstellungsflächen und DVD- und CD-Stores, die sich an der Passage im verglasten Erdgeschoss aufreihen.

Le complexe du producteur Martin Karmitz est devenu le nouveau centre de la « ZAC Rive Gauche » de 130 hectares. Le bâtiment n'héberge pas seulement 14 cinémas, mais aussi trois restaurants de classes de prix différentes, un bar, des surfaces d'exposition et des magasins de DVD et de CD, qui s'alignent dans la galerie marchande au rez-de-chaussée en verre.

El complejo del productor Martin Karmitz actúa, como el nuevo centro del "ZAC Rive Gauche" que abarca 130 hectáreas. El edificio alberga no solamente 14 cines sino también tres restaurantes de diferentes categorías de precios, un bar, superficies para exposiciones y almacenes de DVD y CD que en la acristalada planta baja se alinean en el pasaje.

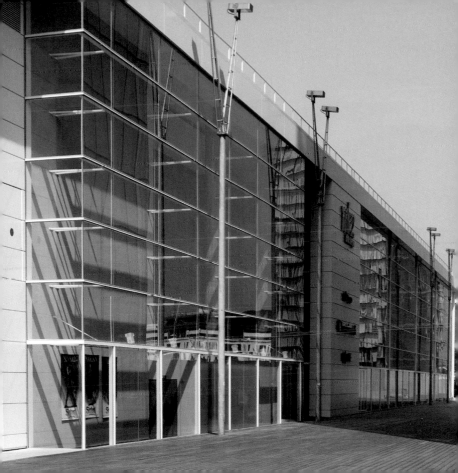

Stade de France

Michel Macary, Aymerica Zubléna (SCAU)
Michel Regembal, Claude Costantini

1998
Saint-Denis la Plaine
Saint-Denis

www.stadefrance.com
www.scau.com
www.costantini-regembal.com

The stadium was built especially for the 1998 football world championships in an industrial wasteland in the northern part of the city. The exterior is 35 meters high and the pitch lies pushed back a further 11 meters. The lower stands can be pushed under the higher terraces when the arena has a greater space requirement.

Das Stadion wurde eigens für die Fußball-WM 1998 in einer Industriebrache im Norden der Stadt geschaffen. Es ist außen 35 Meter hoch und das Spielfeld liegt im Inneren weitere elf Meter eingetieft. Die unteren Tribünen können bei größerem Platzbedarf in der Arena unter die höheren Ränge geschoben werden.

Le stade a été créé spécialement à l'occasion de la Coupe du monde de football en 1998 sur une friche industrielle au Nord de la ville. A l'extérieur, il fait 35 m de haut et à l'intérieur, le terrain se trouve encore 11 mètres en profondeur. Les tribunes inférieures peuvent être repoussées dans l'arène au-dessous des rangées supérieures en cas de besoin en place plus important.

El estadio fue creado expresamente para el campeonato mundial de fútbol de 1998 en un terreno industrial baldío en el norte de la ciudad. En el exterior tiene 35 metros de altura y el campo de juego en el interior tiene once metros más conseguidos mediante excavación. Las tribunas inferiores pueden desplazarse bajo las gradas superiores en caso de necesitar espacio en el estadio.

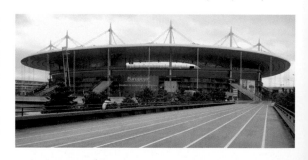

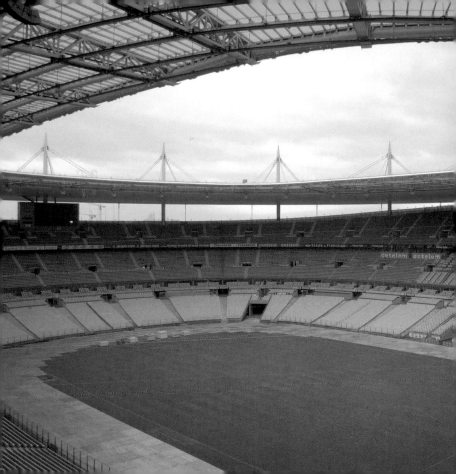

to shop . mall
 retail
 showrooms

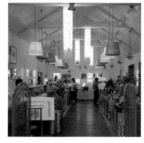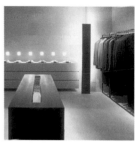
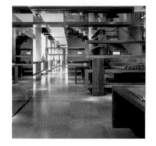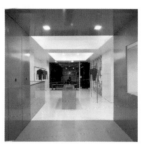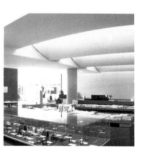
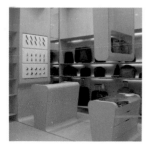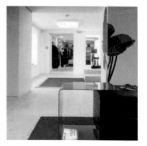

Colette

Arnauld Montigny (Design)

1997
213, rue Saint-Honoré
1. Arrondissement

www.colette.fr
www.ilovecolette.com

Colette is not a store for an individual manufacturer but sells both its own creations as well as selected products from other manufacturers of fashion, design, music, and literature. Still, it has the flair of a flagship store and correspondingly a gallery and the first Paris mineral water bar.

Colette ist kein Store eines einzelnen Herstellers, sondern vertreibt sowohl eigene Creationen als auch ausgesuchte Produkte anderer Hersteller aus Mode, Design, Musik und Literatur. Dennoch hat es das Flair eines Flagship-Stores und dementsprechend runden eine Galerie und die erste Pariser Mineralwasser-Bar das Angebot ab.

Colette n'est pas le magasin d'un fabricant unique, il commercialise aussi bien les propres créations que des produits sélectionnés d'autres fabricants de la mode, du design, de la musique et de la littérature. Il présente néanmoins le flair d'un flagshipstores et l'image est complétée de manière correspondante par une galerie et le premier bar parisien d'eau minérale.

Colette no es un almacén de un solo fabricante sino que vende tanto creaciones propias como productos escogidos de otros fabricantes de moda, diseño, música y literatura. Sin embargo, posee el encanto de un flagshipstore y, en consecuencia, una galería y el primer bar parisino de agua mineral.

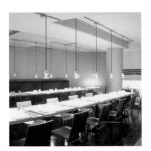

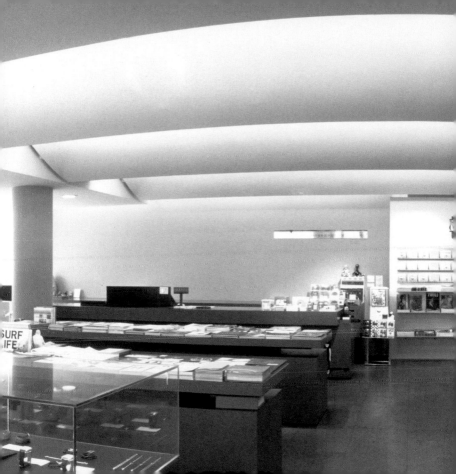

Comme des Garçons Parfums

Rei Kawakubo (Conception and Design)
Takao Kawasaki and Architects Associes (Architecture)

2001
23, place du Marché-Saint-Honoré
1. Arrondissement

www.future-systems.com

Only glass separates the store from the plaza and yet the borders could hardly be more distinct. Starting at the bottom in uncompromising magenta, the panes become almost colorless only in the top third. The tint is more discreet for those looking out and artificial light additionally moderates the effect.

Nur Glas trennt den Store von dem Platz und dennoch könnte die Grenze kaum deutlicher sein. Unten in einem kompromisslosen Magenta beginnend, werden die Scheiben erst im oberen Drittel nahezu farblos. Für Hinaussehende ist die Tönung dezenter und zudem mildert Kunstlicht den Effekt.

Le magasin n'est séparé que par du verre de la place, néanmoins, les limites ne peuvent à peine en être plus claires. Commençant au bas dans un magenta sans compromis, les vitres deviennent presque incolores seulement dans le tiers supérieur. Pour ceux qui regardent à l'extérieur, les tons sont plus décents et de la lumière artificielle finit d'en adoucir l'effet.

Aunque la tienda y la plaza sólo se hallan separadas por una cristalera, la división entre ambas no podría ser más clara. En la parte inferior, los cristales son de color magenta muy llamativo y se van aclarando hasta volverse casi transparentes en el tercio superior. Cuando se mira desde el interior hacia afuera, el color del cristal resulta más tenue, al suavizarse su efecto además con luz artificial.

154

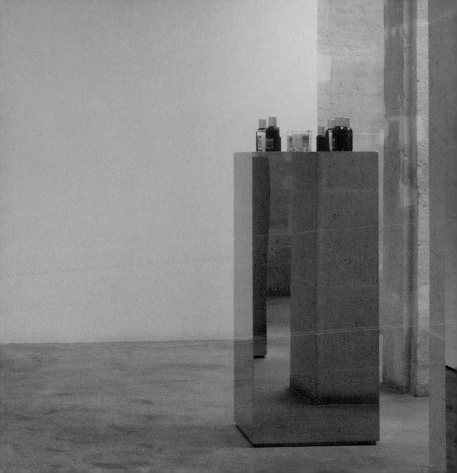

Giorgio Armani

Claudio Silvestrin (Interior design)

1999 (Interior design)
6, place Vendôme
1. Arrondissement

www.giorgioarmani.com
www.claudiosilvestrin.com

The accommodation of the minimalist designed store strikes one as virtually antithetical in one of the buildings of the first kingly plazas of the Baroque "Classicisme". The pure room with its strict joints and edges as well as the precise angling reveals no borders, not to mention any kind of decoration or embellishments.

Geradezu antithetisch mutet die Unterbringung des minimalistisch gestalteten Geschäfts in einem der Bauten des ersten Königsplatzes des barocken „Classicisme" an. Der reine Raum mit seinen scharfen Fugen und Kanten sowie exakten Winkeln zeigt keinerlei Leisten, geschweige denn irgendwelche Dekorationen oder Schnörkel.

C'est une impression presque antithétque que donne le magasin aménagé de manière minimaliste abrité dans l'un des édifices de la première place royale du classicisme baroque. Avec ses joints et bordures précis ainsi que des angles exacts, la salle pure ne montre aucune barre, ni aucune ornement ou décoration.

El alojamiento de la tienda formada de manera minimalista en uno de los edificios de la primera plaza real del "Classicisme" barroco causa una impresión casi antitética. El espacio puro con sus esquinas y uniones afilados no muestra ninguna viga, menos aún algunas decoraciones u ornamentos.

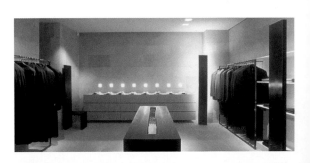

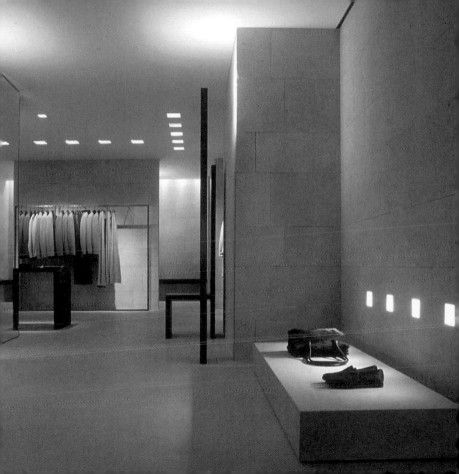

Immeuble Pont-Neuf Kenzo

Deuxl, Lena Pessoa, Vudafieri Partners, Simona Quadri (Store Kenzo)

2003
1, rue du Pont-Neuf /
75, rue de Rivoli
1. Arrondissement

www.kenzo.com
www.deuxl.com
www.vudapartners.com

The Kenzo flagship store is found in one of the La Samaritaine department store buildings, which belongs to the same group. Restaurants and beauty center represent various facets of the Kenzo brand. In the center stands the actual Kenzo store, which, with its flowers, greens, and various paths, reminds one of the Japanese art of gardening.

Le Flagship-Store de Kenzo se trouve dans l'une des constructions du grand magasin La Samaritaine, qui appartient au même groupe. Des restaurants et un centre de beauté représentent diverses facettes de la marque Kenzo. Au centre se trouve le vrai magasin Kenzo, qui rappelle l'art des jardins japonais par les fleurs, la verdure et les divers sentiers guidés.

Der Flagship-Store von Kenzo befindet sich in einem der Bauten des Kaufhauses La Samaritaine, das zum gleichen Konzern gehört. Restaurants und Beauty-Center repräsentieren verschiedene Facetten der Marke Kenzo. Im Zentrum steht der eigentliche Kenzo-Store, der mit Blumen, Grün und verschiedenen Wegführungen an japanische Gartenkunst erinnert.

El flagship-store de Kenzo se encuentra en uno de los edificios de los grandes almacenes La Samaritaine que pertenecen al mismo consorcio. Restaurantes y Beauty-Centers representan facetas distintas de la marca Kenzo. En el centro está el verdadero almacén de Kenzo que recuerda al arte de jardinería japonés con flores, verde y caminos diferentes.

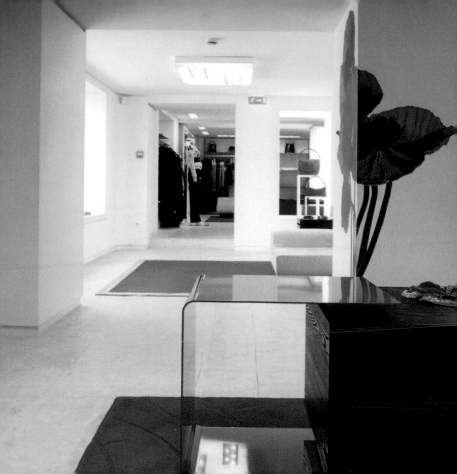

Mandarina Duck

Studio X Design Group (Oscar Brito + Lara Rettondini)

2003
36, rue Étienne-Marcel
2. Arrondissement

www.mandarinaduck.com
www.stxdesign.com

A modular concept in the yellow and white of the brand logo distinguishes the new Paris branch and could be applied to other stores. The so-called "Manda rings", are arranged according to the needs of the salesroom. They include floors, ceilings, and two walls, and form counters and shelves in soft curves.

Ein modulares Konzept im Gelb und Weiß des Markenlogos zeichnet die neuen Pariser Niederlassungen aus und wird auf andere Stores übertragen werden. Sogenannte „Manda-Rings", werden entsprechend der Bedürfnisse des Verkaufsraums aufgestellt. Sie umfassen Böden, Decken und zwei Wände und bilden in weichen Rundungen Theken sowie Regale aus.

Un concept modulaire en jaune et blanc du logo de la marque distingue les nouvelles filiales parisiennes et pourrait être appliqué à d'autres magasins. Les fameux « Manda-Rings », sont disposés conformément aux besoins du local de vente. Ils englobent les sols, les plafonds et deux murs en constituant dans les courbes tendres aussi bien des comptoirs que des étagères.

Un concepto modular en amarillo y blanco del logo de la marca caracteriza las nuevas filiales parisinas y podría ser trasladado a otros almacenes. Los llamados "Manda-Rings", se colocan correspondiendo a las necesidades del local de ventas. Abarcan suelos, techos y dos paredes y forman, en suaves curvaturas, mostradores así como estanterías.

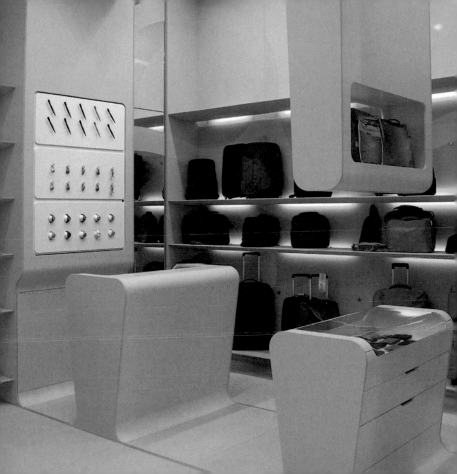

Librairie Florence Loewy

Dominique Jakob + Brendan Macfarlane

2001
9-11, rue de Thorigny
3. Arrondissement

www.florenceloewy.com

The bookshop, specialized in books by artists, appears to be a work of art itself. The partially accessible shelves resemble sculptures. While their exterior form is shaped from flowing, winding lines, the inner structure of the individual shelves is formed by a mostly rigid spatial system of coordinates.

Die auf Bücher von Künstlern spezialisierte Buchhandlung erscheint selbst als Kunstwerk. Die teilweise begehbaren Regale ähneln Skulpturen. Während ihre Außenform aus fließenden, sich windenden Linien gebildet wird, ergibt sich die Binnenstruktur der einzelnen Regalbretter aus einem weitgehend festen räumlichen Koordinatensystem.

La librairie spécialisée dans les livres d'artistes apparaît elle-même comme une œuvre d'art. Les étagères en partie sur lesquelles on peut monter ressemblent à des sculptures. Alors que leur forme extérieure est constituée de lignes coulantes s'entrelaçant, la structure intérieure des plans d'étagères individuels résulte d'un système de coordination spatiale largement fixe.

Esta librería especializada en libros de artistas es una obra de arte en sí misma. Algunas de las estanterías en las que uno puede caminar se asemejan a esculturas. Mientras que su forma exterior está formada por líneas fluctuantes y retorcidas, la estructura interior de cada uno de los estantes está compuesta por un sistema de coordenadas de espacio fijo.

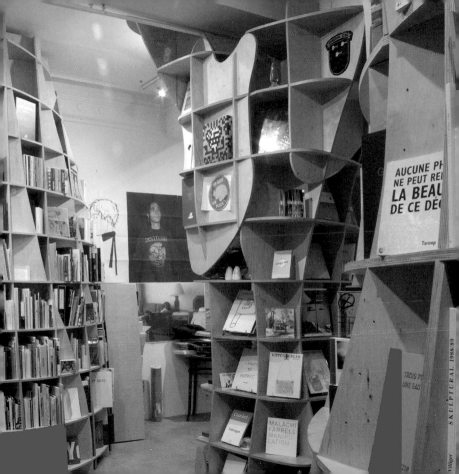

Pleats Please Issey Miyake

Gwenaël Nicolas, Curiosity

1999
3bis, rue des Rosiers
4, Arrondissement

www.pleatsplease.com
www.isseymiyake.com
www.curiosity.co.jp

Using strict geometric forms, Nicolas created the adequate environment for the line accentuated Miyakes clothing. On the other hand, the architecture's hard materials stand in conscious contrast to the soft fabrics and let the flowing asymmetrical designs appear even livelier.

Mit streng geometrischen Formen schuf Nicolas das adäquate Umfeld für die linienbetonte Kleidung Miyakes. Die harten Materialien der Architektur stehen hingegen in bewusstem Kontrast zu den weichen Stoffen und lassen die Modelle in fließenden Asymmetrien um so lebendiger erscheinen.

C'est avec des formes géométriques austères que Nicolas a créé l'environnement adéquat pour les vêtements à ligne accentuée de Miyake. Les matériaux durs se trouvent en revanche en contraste conscient avec les tissus doux et donnent dans une asymétrie fluide une apparence d'autant plus vivante aux modèles.

Nicolas creó con rigurosas formas geométricas el ambiente adecuado para la ropa de marcadas líneas de Miyake. Los duros materiales de la arquitectura contrastan intencionadamente con las telas blandas y hacen que los modelos en asimetrías fluctuantes parezcan todavía más vivos.

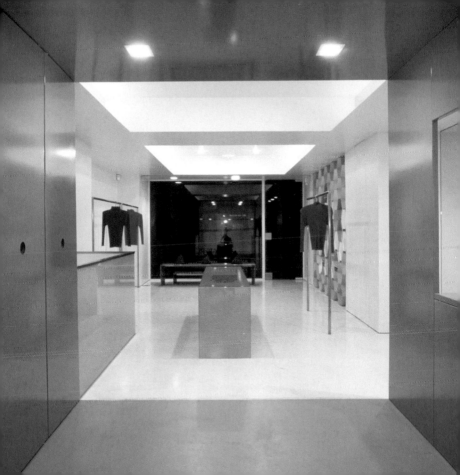

Boutique Momi

Yoshio Sakurai

2000
29, rue des Saints-Pères
6. Arrondissement

www.momi-paris.com
www.design-studio.org

Perhaps the smallest store in Paris comprises a narrow, short passageway and a hardly 1 m² salesroom with a built-in counter. A geometric pattern made of white boards covers the walls and integrates the counter and a mirror. The pieces of jewellery are found in transparent boxes stacked on the counter.

Das wohl kleinste Geschäft in Paris besteht aus einem schmalen, kurzen Gang und einem kaum 1 m² großen Verkaufsraum mit eingebauter Theke. Ein geometrisches Raster aus weißen Platten überzieht die Wände und bindet auch die Theke und einen Spiegel ein. Die Schmuckstücke befinden sich in, auf der Theke gestapelten, durchsichtigen Kästen.

Le magasin qui est bien le plus petit à Paris est composé d'un couloir étroit et court et d'une pièce de vente à peine plus grande qu'1 m² avec comptoir intégré. Une grille en plaques blanches recouvre les murs et relie également le comptoir et un miroir. Les parures se trouvent dans des cadres transparents, empilés sur le comptoir.

La tienda más pequeña de París está compuesta de un pasillo estrecho y corto y de una superficie de venta de apenas 1m² con mostrador incluido. Una trama geométrica de placas blancas recubre las paredes integrando el mostrador y un espejo. Las joyas se encuentran dentro de cajas transparentes apiladas sobre el mostrador.

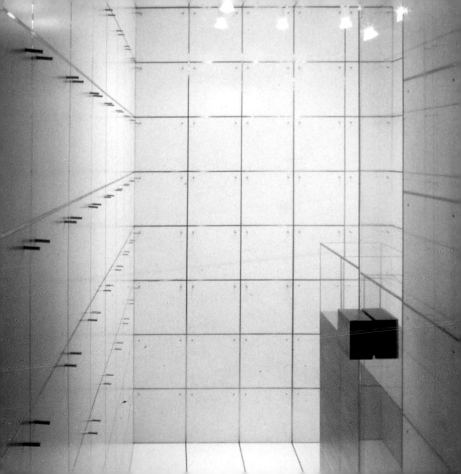

Comme des Garçons
Red-Boutique

Rei Kawakubo (Conception and Design)
Takao Kawasaki and Architects Associes (Architecture)
KRD (Pavilion Design, Boutique Design Consultant)

2001
54, rue du Faubourg-Saint-Honoré
8. Arrondissement

Hidden in a second rear courtyard, only the sporadic red, as a small square on the street and as a disguising wall behind the window opening shows the way into the "Red Store". Following the blue store in Tokyo and the white one in New York, this branch is dominated by blood-red fibreglass.

Versteckt in einem zweiten Hinterhof gelegen, zeigt nur das sporadische Rot als kleines Quadrat an der Straße und als verstellende Wand hinter Fensteröffnungen den Weg in den „Red-Store". Nach dem blauen Geschäft in Tokyo und dem weißen in New York wird diese Niederlassung von blutrotem Fiberglas dominiert.

Dissimulé dans une deuxième arrière-cour, seul le rouge sporadique du petit carré sur la rue et de la paroi amovible derrière les ouvertures de fenêtre indique le chemin au « Red-Store ». Après le magasin bleu à Tokyo et le blanc à New York, cette filiale est dominée de fibre de verre rouge sanguin.

Oculta en un segundo patio interior, sólo el rojo esporádico del pequeño cuadrado en la calle como pared disimulante detrás de unas ventanas muestra el camino hacia la "Red-Store". Tras la tienda azul en Tokio y la blanca en Nueva York, este establecimiento es dominado por la fibra de vidrio de color rojo vivo.

Espace d'exposition Citroën

Manuelle Gautrand

2005
42, avenue des Champs-Élysées
8. Arrondissement

www.citroen.mb.ca/citroenet/champ
selysees/paris-showroom.html
www.manuelle-gautrand.com

Spanned between neighbouring structures, the glass showroom has an effect like an unfolding, hydraulic lift. At the same time, the kinks in the glass skin replicate a metamorphosis of the Citroen emblem to the lozenge structure. A red "automobile shelf", accessible via a flowing white level, dominates the interior area.

Zwischen den Nachbarbauten eingespannt wirkt der gläserne Showroom wie eine sich entfaltende, hydraulische Hebebühne. Dabei bilden die Knicke der Glashaut eine Metamorphose des Citroën-Emblems zur Rautenstruktur nach. Ein über fließende, weiße Ebenen zugängliches, rotes „Auto-Regal" dominiert den Innenraum.

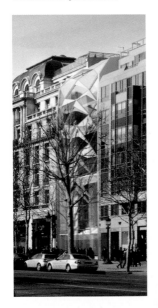

Déployé entre les constructions voisines, le showroom en verre fait l'effet d'une scène élévatrice hydraulique se dépliant. Les plis de la peau de verre y dessinent la transformation de l'emblème Citroën vers la structure en dièse. Une « étagère auto » accessible par des plans fluides blancs domine l'espace intérieur.

Tendido entre los edificios limítrofes, el showroom de vidrio tiene el aspecto de una plataforma hidráulica de elevación. Los vértices de la estructura de vidrio imitan una transformación del emblema de Citroën en una estructura romboidal. El espacio interior está dominado por una "estantería de automóviles" roja accesible a través de varios niveles blancos y fluctuantes.

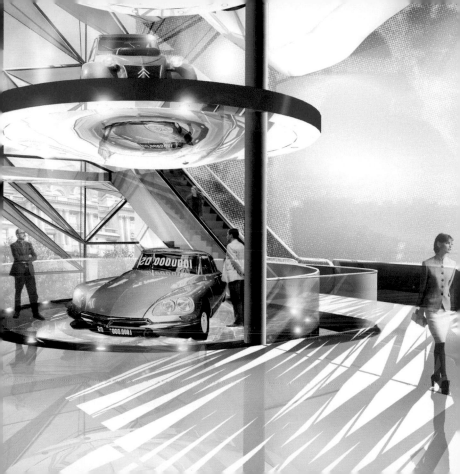

Fendi

Claudio Lazzarini & Carl Pickering

2001
24, rue François 1er
8. Arrondissement

www.fendi.it

Fendis new modular furnishing concept can be flexibly adapted to various room situations. The shelving elements—up to 10 m long—are interlocked spanning across the rooms and thus generate an independent architecture within the building. This culminates around the staircase where the furniture creates a tower.

Fendis neues modulares Einrichtungskonzept lässt sich flexibel verschiedenen Raumsituationen anpassen. Die Regalelemente von bis zu 10 m Länge werden raumübergreifend verschachtelt und erzeugen so eine eigenständige Architektur innerhalb des Gebäudes. Dies kulminiert rund um den Treppenaufgang, wo die Möblierung einen Turm ausbildet.

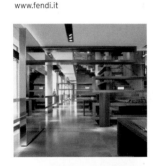

Le nouveau concept d'aménagement modulaire de Fendis peut être adapté à différentes situations spatiales. Les éléments d'étagères de jusqu'à 10 m de long sont encastrés d'une pièce à l'autre et créent ainsi une architecture indépendante à l'intérieur du bâtiment. Celle-ci culmine autour de l'accès à l'escalier, où le mobilier constitue une tour.

El nuevo concepto de decoración modular de Fendi se adapta de forma flexible a las más distintas situaciones espaciales. Los elementos de la estantería de hasta 10 m de longitud se intrincan entre ellos creando una arquitectura propia dentro del edificio. Ello culmina alrededor de la escalera, donde los muebles forman una torre.

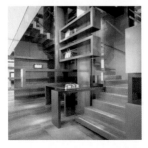

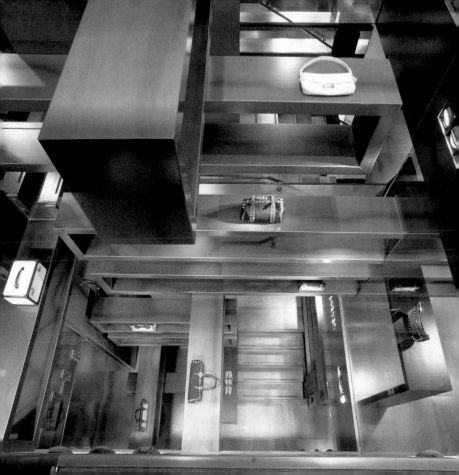

L'Atelier Renault

Franck Hammoutène

2000
53, avenue des Champs-Élysées
8. Arrondissement

www.atelier-renault.com

This studio is less a matter of a classical showroom. On the contrary, it is a public space with alternating interior design in which one can get informed about the automobile maker's motives and visions in an entertaining way or just drink a cup of coffee with a view of the Champs-Élysées.

Bei dem Atelier handelt es sich weniger um einen klassischen Showroom, als vielmehr um einen öffentlichen Raum mit wechselndem Interieur-Design, in dem man sich unterhaltsam über die Motive und Visionen des Autobauers informieren oder auch nur mit Blick über die Champs-Élysées einen Kaffee trinken kann.

Il s'agit pour cet atelier moins d'un showroom classique que d'un espace publique avec design d'intérieur variable, dans lequel on peut s'informer de manière divertissante sur les motifs et les visions du constructeur automobile ou simplement déguster un café avec vue sur les Champs-Élysées.

Este estudio no se trata de un showroom clásico sino más bien de una sala pública con un diseño interior cambiante en el que el visitante puede informarse de forma amena sobre los motivos y visiones del constructor de automóviles o simplemente tomar un café con vistas a los Campos Elíseos.

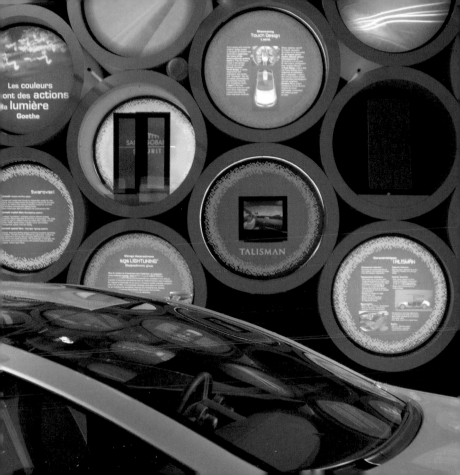

Centre Commercial Bercy Village

Denis Valode & Jean Pistre

1994
Cour Saint-Émilion
12. Arrondissement

www.bercyvillage.com
www.pavillons-de-bercy.com
www.valode-et-pistre.com

Through the changed utilization of an old wine storeroom, a new shopping centre with the character of a village pedestrian-precinct has emerged. The old stone cottages were complemented by new buildings that, distinctly contrasted from the old buildings but in the gable continuation entirely fit in with the existing assets.

Durch die Umnutzung eines alten Weinlagers entstand ein neues Einkaufszentrum mit dem Charakter einer dörflichen Fußgängerzone. Die alten Steinhäuschen wurden mit Neubauten ergänzt, die sich deutlich von den Altbauten absetzen, in der engen Giebelfolge jedoch ganz dem Bestand entsprechen.

Grâce au changement d'utilisation d'une ancienne cave à vin a été créé un nouveau centre commercial avec le caractère d'une zone piétonnière villageoise. Les anciennes maisonnettes ont été complétées par des nouvelles constructions qui, se distinguent clairement des constructions anciennes tout en s'adaptant complètement aux bâtiments existants dans la suite étroite de pignons.

Mediante la redecoración de un antiguo almacén de vinos se creó un nuevo centro comercial con el carácter de una zona peatonal aldeana. Las antiguas casitas de piedra se completaron con nuevas construcciones que, se diferencian claramente de las construcciones antiguas, aun que por otro lado, se adaptan a ellas en cuanto a la secuencia de frontones.

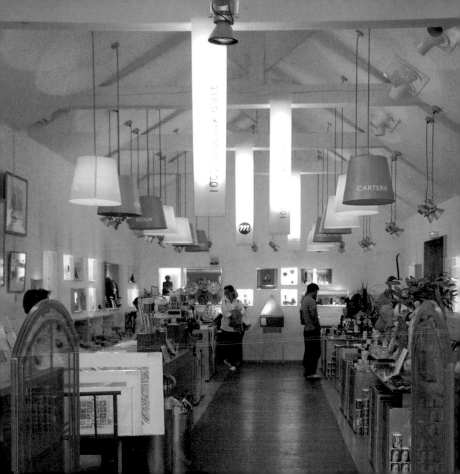

Le Viaduc des Arts

Patrick Berger

1995
Avenue Daumesnil
12. Arrondissement

www.viaduc-des-arts.com

In the arches of a railroad viaduct only business that deal with arts and crafts, antiques, and hand-crafted production were built next to some cafés. The new business fronts fit discreetly into the substance with large-scale glazing, red-brownish wooden frames, and graceful marquees.

In den Bögen eines Eisenbahn-viadukts wurden neben einigen Cafés nur Geschäfte eingebaut, die sich mit Kunsthandwerk, Antiquitäten und handwerklicher Produktion befassen. Die neuen Geschäftsfronten fügen sich mit großflächiger Verglasung, rot-bräunlichen Holzrahmen und zierlichen Vordächern dezent in die Substanz ein.

Dans les arcs d'un viaduc ferro-viaire ont été construits à côté de quelques cafés seulement des magasins se consacrant à l'arti-sanat artistique, aux antiquités et à la production artisanale. Les nouveaux frontons de magasins s'intègrent de manière décente dans la substance avec un vi-trage de surface étendu, des ca-dres de bois brun rouge et des avant-toits fins.

En los arcos del viaducto del fe-rrocarril se construyeron, apar-te de algunos cafés, sólo tiendas dedicadas a la artesanía, las antigüedades y la producción artesanal. Con sus superficies acristaladas, sus marcos de ma-dera castaño-rojizos y sus deli-cados aleros, las nuevas facha-das de las tiendas se adaptan de forma discreta a la substancia existente.

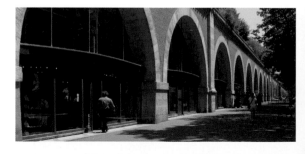

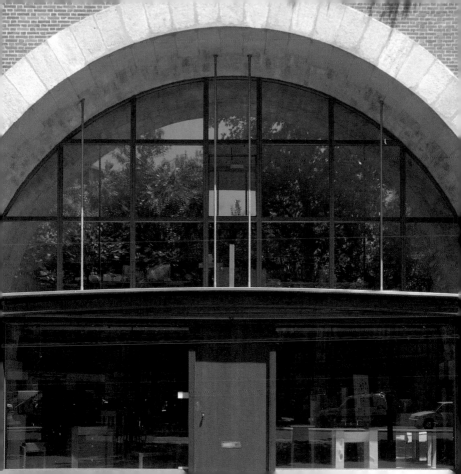

Sephora Bercy

Jean-Marie Massaud, Chafik Gasmi

2000
14, cour Saint-Émilion
12. Arrondissement

www.sephora.com
www.massaud.com

The Sephora shop in Bercy Village is made of a series of rooms, whose surface area is rounded off by the large fitted-shelves on the walls. Together with the huge lampshades, harmonizing lighting, and the succession of circular presentation tables, a continuous spatial concept has been attained.

Der Sephora-Shop in Bercy Village besteht aus einer Folge von Räumen, deren Grundfläche durch die großen Einbauregale an den Wänden gerundet wird. Zusammen mit den riesigen Lampenschirmen, vereinheitlichender Beleuchtung und der Abfolge von kreisrunden Präsentationstischen gelingt es, ein durchgängiges Raumkonzept aufzubauen.

Le magasin Sephora à Bercy Village est composé d'une suite de pièces dont la surface au sol est arrondie par les grandes étagères encastrées sur les murs. Les gigantesques abat-jours, l'éclairage unissant et la suite de tables de présentation circulaires réussissent à construire un concept de pièce régulier et clair.

La tienda de Sephora en Bercy Village está compuesta por una serie de salas, cuya superficie queda redondeada gracias a las enormes estanterías empotradas en las paredes. Junto con las enormes pantallas, la iluminación homogénea y la sucesión de mesas de presentación redondas, se ha conseguido crear un concepto espacial continuo.

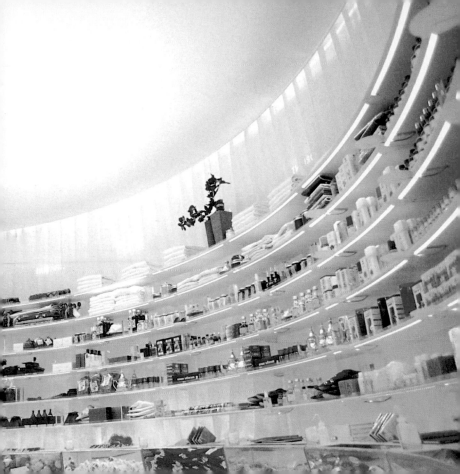

Index Architects / Designers

Name	Location	Page
Agence des gares SNCF	Gare du Nord	74
	Aéroport Charles de Gaulle Roissy-2 Gare RER et TGV	98
Ando, Tadao	UNESCO	54
	Fondation d'art contemporain François Pinault	68
Andreu, Paul	La Grande Arche	32
	Aéroport Charles de Gaulle Roissy-2	98
Architecture Studio	Maison de Retraite	16
	Résidence Universitaire Croisset	20
	Institut du Monde Arabe	50
	Notre-Dame de l'Arche d'Alliance	84
Arquitectonica	Exaltis Tower	30
arte-charpentier et associés	Lentille Météor St.-Lazare	95
Atelier Parisien d'Urbanisme	Parc de Bercy	78
Aubert, André	Palais de Tokyo	62
Basset, Christian	Saint-Luc	92
Battesti, Nathalie	Bel-Ami	110
Berger, Patrick	Parc André-Citroën	88
	Le Viaduc des Arts	178
Biecher, Christian	Pavillon de l'Arsenal	44
	Joe's Café à Joseph	128
Bofill, Ricardo – Taller de Arquitectura	Place du Marché-Saint-Honoré	26
	Hôtel Costes K	116
Borel, Frédéric	Rue Pelleport	24
Botta, Mario	Cathédrale de la Résurrection	102
Bovard, Roger	La Maison Blanche	132
Breuer, Marcel	UNESCO	54
Brito, Oscar	Mandarina Duck	160
Brun, François	Le Jardin Atlantique	86
cabinet ROOM	La Cantine du Faubourg	130
Canal	Pershing Hall	114
Cattani, Alberto	UGC Cine Cité	144
Cattani et Associés, Emanuel	Fondation Cartier pour l'Art Contemporain	58
Chatron, Jules	Musée national des Arts asiatiques-Guimet	60
Christo-Foroux, A.	Jardin Hector Malot	82
Clément, A.	Pavillon de l'Arsenal	44
Clément, Gilles	Musée du Quai Branly	52
	Parc André-Citroën	88
Cobb, Henry	Tour EDF	34
Colboc, Pierre	Jardin de Reuilly	82
Conran, Terence	La Trémoille	112
Cooren, A + A	Shiseido la Beauté	142
Costantini, Claude	Stade de France	148
Curiosity	Pleats Please Issey Miyake	164
Dastugue, Marcel	Palais de Tokyo	62
Deuxl	Immeuble Pont-Neuf Kenzo	158
Dondel, J.-Claude	Palais de Tokyo	62
Duthilleul, Jean-Marie	Gare du Nord	74
	Aéroport Charles de Gaulle Roissy-2 Gare RER et TGV	98
Duval, Georges	Le Grand Louvre	40
Fainsilber, Adrien	Cité des Sciences et de l'Industrie	66
Feichtinger Arch., Dietmar	Passerelle Bercy-Tolbiac	80

Name	Location	Page
Ferran, Marylène	Parc de Bercy	78
Feugas, Jean-Pierre	Parc de Bercy	78
Fort-Brescia, Bernardo	Exaltis Tower	30
Franchini, Gianfranco	Centre Georges-Pompidou	46
Fuksas, Massimiliano	Îlot Candie Saint-Bernard	14
Gabriel, Jaques-Ange	Mur pour la Paix	72
Gasmi, Chafik	Sephora Bercy	180
Gaudin, Henri et Bruno	Musée national des Arts asiatiques-Guimet	60
Gautrand, Manuelle	Espace d'exposition Citroën	170
Groupe Paysages	Jardin de Reuilly	82
Grumbach, Antoine	Métro Bibliothèque nationale de France	96
Hajjaj, Hassan	Andy Wahloo	122
Halter, Clara	Mur pour la Paix	72
Hammoutène, Franck	Cité de la Musique	64
	Notre-Dame-de-la-Pentecôte	100
	La Maison Blanche	132
	L'Atelier Renault	174
Herzog & de Meuron	Logements sociaux rue des Suisses	18
Hittorff, Jakob Ignaz	Gare du Nord	74
Huet, Bernhard	Parc de Bercy	78
Huyghe, Pierre	Étienne Marcel	120
Hybert, Fabrice	Hôtel Costes K	116
Jakob, Dominique	Georges	124
	Librairie Florence Loewy	162
Jodry et Associés, Jean-François	Parc André-Citroën	88
Jouannet, Michel	Bel-Ami	110
Karavan, Dani	UNESCO	54
Kawakubo, Rei	Comme des Garçons Parfums	154
	Comme des Garçons Red-Boutique	168
Kawasaki and Architects Ass.	Comme des Garçons Parfums	154
	Comme des Garçons Red-Boutique	168
KRD	Comme des Garçons Red-Boutique	168
Kurokawa, Kisho	Tour Pacific et Pont Japon	36
Lacaton, Anne	Palais de Tokyo	62
Lazzarini, Claudio	Fendi	172
Legrand, Bruno	Notre-Dame-d'Espérance	76
Leo-Andrieu, Grace	Bel-Ami	110
Leroy, Bernard	Parc de Bercy	78
Lézenès, Gilbert	Institut du Monde Arabe	50
M/M Paris	Étienne Marcel	120
Macary, Michel	Le Grand Louvre	40
	Stade de France	148
Macfarlane, Brendan	Georges	124
	Librairie Florence Loewy	162
Marinet, Richard	La Trémoille	112
Martin-Trottin, Emmanuelle	Centre Georges-Pompidou	46
Massaud, J.-Marie	Sephora Bercy	180
Mathieux, Philippe	Promenade plantée	82
Mimram, Marc	Passerelle Solférino	70

Index Architects / Designers

Name	Location	Page
Montel, Pierre-Henri	Saint-Luc	92
Montigny, Arnauld	Colette	152
Namur, Frédéric	MK2 Bibliothèque	146
Nervi, Pier Luigi	UNESCO	54
Nicolas, Gwenaël	Pleats Please Issey Miyake	164
Nouvel, Jean	Institut du Monde Arabe	50
	Musée du Quai Branly	52
	Fondation Cartier pour l'Art Contemporain	58
Othoniel, Jean-Michel	Kiosque de Noctambules	97
Parreno, Philippe	Étienne Marcel	120
Pei Cobb Freed and Partners	Tour EDF	34
	Le Grand Louvre	40
Pei, Ieoh Ming	Le Grand Louvre	40
Pena, Michel	Le Jardin Atlantique	86
Périphériques	Centre Georges-Pompidou	46
Perrault, Dominique	Bibliothèque nationale de France Site François Mitterrand	56
Perret, Auguste	La Maison Blanche	132
Perrier, Alain	Artus Hôtel	106
Pessoa, Lena	Immeuble Pont-Neuf Kenzo	158
Piano, Renzo	Centre Georges-Pompidou	46
Pickering, Carl	Fendi	172
Pira	La Cantine du Faubourg	130
Pistre, Jean	Tour t1	38
	UGC Cine Cité	144
	Centre Commercial Bercy Village	176

Name	Location	Page
Portzamparc, Christian de	Cité de la Musique	64
Portzamparc, Elizabeth de	Les Grandes Marches	138
Provost, Allain	Parc André-Citroën	88
Putman, Andrée	Pershing Hall	114
	Lô Sushi	136
Quadri, Simona	Immeuble Pont-Neuf	158
Rahmouni, Imaad	La Maison Blanche	132
	La Suite	134
Regembal, Michel	Stade de France	148
Rettondini, Lara	Mandarina Duck	160
Rogers, Richard	Centre Georges-Pompidou	46
Saee, Michele	Café Nescafé	140
Sakurai, Yoshio	Boutique Momi	166
Schall, Pierre	Bibliothèque nationale de France	96
Schoenert, Axel	La Cantine du Faubourg	130
Silvestrin, Claudio	Giorgio Armani	156
Soria, Pierre	Institut du Monde Arabe	50
Sprekelsen, Johann-Otto von	La Grande Arche	32
Studio X Design Group	Mandarina Duck	160
Tahir, Abbès	Lentille Météor St.-Lazare	95
Tectône	Tour Totem	22
Terreaux, Veronique	Bel-Ami	110
Tricaud, Etienne	Gare du Nord	74
	Aéroport Charles de Gaulle Roissy-2 Gare RER et TGV	98
Trottin, David	Centre Georges-Pompidou	46

Name	Location	Page
Tschumi, Bernard	Parc de la Villette	90
Valode, Denis	Tour t1	38
	UGC Cine Cité	144
	Centre Commercial Bercy Village	176
Vassal, Jean-Philippe	Palais de Tokyo	62
Velde, Henry van de	La Maison Blanche	132
Vergely, Jacques	Promenade plantée	82
Viard, Paul-Jean-Emile	Palais de Tokyo	62

Name	Location	Page
Viguier, Jean-Paul	Cœur Défense	28
	Parc André-Citroën	88
Vudafieri Partners	Immeuble Pont-Neuf Kenzo	158
Wilmotte, Jean Michel	Le Grand Louvre	40
	Mur pour la Paix	76
	MK2 Bibliothèque	146
Zehrfuss, Bernhard	UNESCO	54
Zubléna, Aymerica	Stade de France	148

Index Districts

District	No.	Building / Location	Address	Page
1. Arrondissement	07	Place du Marché-Saint-Honoré	Place du Marché-Staint-Honoré	26
	14	Le Grand Louvre	99, rue de Rivoli / place du Carrousel	40
	26	Passerelle Solférino	Quai de Tuileries / quai Anatole-France	70
	41	Kiosque de Noctambules	Métro Palais Royal-Musée du Louvre	97
	64	Colotte	213, rue Saint-Honoré	152
	65	Comme des Garçons Parfums	23, place du Marché-Saint-Honoré	154
	66	Giorgio Armani	6, place Vendôme	156
	67	Immeuble Pont-Neuf Kenzo	1, rue du Pont-Neuf / 75, rue de Rivoli	158
2. Arrondissement	50	Étienne Marcel	34, rue Étienne-Marcel	120
	68	Mandarina Duck	36, rue Étienne-Marcel	160
3. Arrondissement	51	Andy Wahloo	69, rue des Gravilliers	122
	69	Librairie Florence Loewy	9-11, rue de Thorigny	162
4. Arrondissement	15	Pavillon de l'Arsenal	21, boulevard Morland	44
	16	Centre Georges-Pompidou	19, rue Beaubourg	46
	52	Georges	19, rue Beaubourg	124
	70	Pleats Please Issey Miyake	3bis, rue des Rosiers	164
5. Arrondissement	17	Institut du Monde Arabe	1, rue des Fossés-Saint-Bernard	50
6. Arrondissement	45	Artus Hôtel	34, rue de Buci	106
	46	Bel-Ami	7-11, rue Saint-Benoît	110
	71	Boutique Momi	29, rue des Saints-Pères	166

185

Index Districts

District	No.	Building / Location	Address	Page
7. Arrondissement	18	Musée du Quai Branly	Quai Branly	52
	19	UNESCO	Place de Fontenoy	54
	28	Mur pour la Paix	Parc du Champ de Mars / place Joffre	72
8. Arrondissement	39	Lentille Météor St.-Lazare	Métro St.-Lazare	94
	47	La Trémoille	14, rue de la Trémoille	112
	48	Pershing Hall	49, rue Pierre-Charron	114
	53	Joe's Café à Joseph	277, rue Saint-Honoré	128
	54	La Cantine du Faubourg	105, rue du Faubourg-Saint-Honoré	130
	55	La Maison Blanche	15, avenue Montaigne	132
	56	La Suite	40, avenue Georges V	134
	57	Lô Sushi	8, rue de Berri	136
	60	Shiseido la Beauté	3-5, boulevard Malesherbes	142
	72	Comme des Garçons Red-Boutique	54, rue du Faubourg-Saint-Honoré	168
	73	Espace d'exposition Citroën	42, avenue des Champs-Élysées	170
	74	Fendi	24, rue François 1er	172
	75	L'Atelier Renault	53, avenue des Champs-Élysées	174
10. Arrondissement	29	Gare du Nord	Place Napoléon III	74
11. Arrondissement	01	Îlot Candie Saint-Bernard	Rue de Candie / pass. Saint-Bernard	14
	02	Maison de Retraite	28-30, rue Morand / 2-4, rue Desargues	16
	30	Notre-Dame-d'Espérance	47, rue de la Roquette / rue du Commandant-Lamy	76
12. Arrondissement	31	Parc de Bercy	Quai de Bercy / rue Joseph-Kessel	78
	32	Passerelle Bercy-Tolbiac	Quai François-Mauriac / quai de Bercy	80
	33	Promenade plantée	Avenue Daumesnil	82
	58	Les Grandes Marches	6, place de la Bastille	138
	61	UGC Cine Cité	114, quai de Bercy / 2-8, rue François-Truffaut	144
	76	Centre Commercial Bercy Village	Cours Saint-Émilion	176
	77	Le Viaduc des Arts	Avenue Daumesnil	178
	78	Sephora Bercy	14, cours Saint-Emilion	180
13. Arrondissement	20	Bibliothèque nationale de France Site François Mitterrand	Quai François-Mauriac	56
	40	Métro Bibliothèque nationale de France		96

District	No.	Building / Location	Address	Page
13. Arrondissement	62	MK2 Bibliothèque	128/162, avenue de France	146
14. Arrondissement	03	Rue des Suisses	19, rue des Suisses / 4, rue Jonquoy	18
	22	Fondation Cartier pour l'Art Contemporain	261, boulevard Raspail	58
15. Arrondissement	34	Notre-Dame de l'Arche d'Alliance	81, rue d'Alleray	84
	35	Le Jardin Atlantique	Place des Cinq-Martyrs-du-Lycée-Buffon	86
	36	Parc André-Citroën	Quai André-Citroën	88
16. Arrondissement	22	Musée national des Arts asiatiques-Guimet	6, place d'Iéna	60
	23	Palais de Tokyo	13, avenue du Président Wilson	62
	49	Hôtel Costes K	81, avenue Kléber	116
17. Arrondissement	59	Café Nescafé	15, avenue de Wagram	140
18. Arrondissement	04	Résidence Universitaire Croisset	4-8, rue Francis-de-Croisset	20
19. Arrondissement	05	Tour Totem	29, avenue de Flandre / rue du Maroc	22
	24	Cité de la Musique	213-221, avenue Jean-Jaurès	64
	25	Cité des Sciences et de l'Industrie	30, avenue Corentin-Cariou	66
	37	Parc de la Villette	Av. Jean-Jaurès / galerie de l'Ourcq	90
	38	Saint-Luc	80, rue de l'Ourcq / pass. Wattoaux	92
20. Arrondissement	06	Rue Pelleport	129, rue Pelleport / 15, rue des Pavillons	24
Boulogne-Billancourt	26	Fondation d'art contemporain François Pinault	Île Seguin	68
Evry, Corbeil-Essonne	44	Cathédrale de la Résurrection	Cour Monseigneur Romero / place des Droits de l'Homme et du Citoyen	102
La Défense	08	Cœur Défense	Esplanade de La Défense	28
	09	Exaltis Tower	1, place de la Coupole	30
	10	La Grande Arche	1, parvis de la Défense	32
	11	Tour EDF	20, place de la Défense	34
	12	Tour Pacific et Pont Japon	11-13, cours Valmy	36
	13	Tour t1		38
	43	Notre-Dame-de-la-Pentecôte	Parvis de la Défense	100
Roissy	42	Aéroport Charles de Gaulle Roissy-2		98
Saint Denis	63	Stade de France	Saint-Denis la Plaine	148

Photo Credits

Photographer	Pages
Ando, Tadao	54, 55, 68, 69
archipress	11, 126, 127
Architecture Studio	2, 16 (d), 17, 20 (d)
	50 (d), 84 (d), 85
AREP	94 (d)
Arquitectonica	30 (d), 31
Artefactory	52 (d), 53
Artus Hôtel Archive	106, 107, 108, 109
Attal, Jean-Pierre	36
Bauer, Roland	4, 6, 11
Bel-Ami Archive	110
Biecher, Christian	44 (d), 128 (d), 129
Bordina, Olivier	150, 151
Borel, Frédéric	24 (d)
Borel, Nicolas	24, 25, 160
Botta, Mario	102 (d), 103
Boy de la Tour, Didier	95
Buzzoni, Marco	Cover, 26
CSI, Michel Lamoureux,	
Adrien Fainsilber architecte	67
Delhaste, Theo	5, 110, 111, 164, 165
Feichtinger Architectes	80 (d), 81
Fessy, Geroges	143, 144, 145, 176
Gautrand, Manuelle	170
Gizmo	171
Hammoutène, Franck	174 (d)
Horiuchi, Koji	166
Hôtel Costes K	116, 117
Jacob + Macfarlane	124 (d), 162
Kunz, Martin N.	9
Kurokawa, Kisho	36 (d)
La Trémoille Archive	112, 113
Lazzarini Pickering	172 (d)
Lézenès, Gilbert	50
Loft Publications	4, 124, 125, 126
	132, 133, 135
Martin, Hanna	8, 50, 51, 78, 79, 89
Massaud, Jean-Marie	180, 181
Michel, Denacé	47
Mimram, Marc	70 (d)
Monthier, Jean-Marie	44, 45, 70, 71
Musi, Pino	102, 103
Nouvel, Jean	8, 50, 52
Pershing Hall Archive	114, 115
Piazza, Matteo	172, 173
Rahmouni, Imaad	134
Rand, Marvin	140, 141
Saee, Michele	140 (d)
Sovia, Prè	143
Silvestrin, Claudio - Archive	156, 157
Studio X Design Group	161
Tectône	22 (d)
Valode & Pistre Architectes	38, 39, 144 (d)
Uffelen, Christian van	10, 14, 15, 16
	18, 19, 20 (t), 21, 22 (b), 23, 27, 28 (b), 29
	32 – 35, 37, 40 – 43, 46, 48, 49, 56 – 66
	72 – 77, 78 (b), 79, 82 – 88, 90 – 93, 96 – 101
	120 – 123, 130, 136 – 139, 142, 146 – 149
	151, 154, 155, 160, 163, 164 (t), 166 – 169
	175, 177 – 179
Viguier, Jean-Paul	28 (d), 88 (d)
Vudafieri Partners, Deuxl Paris	158, 159

(t) - top; (b) - bottom; (l) - left; (r) - right; (d) drawing

Imprint

Copyright © 2005 teNeues Verlag GmbH & Co. KG, Kempen

teNeues Book Division
Kaistraße 18
40221 Düsseldorf, Germany
Phone: 0049 (0)211-99 45 97-0
Fax: 0049-(0)211-99 45 97-40
E-mail: books@teneues.de

teNeues Publishing Company
16 West 22nd Street
New York, N.Y. 10010, USA
Phone: 001-212-627-9090
Fax: 001-212-627-9511

teNeues France S.A.R.L.
4, rue de Valence
75005 Paris, France
Phone: 0033-1-55 76 62 05
Fax: 0033-1-55 76 64 19

Press department: arehn@teneues.de
Phone: 0049-(0)2152-916-202

teNeues Publishing UK Ltd.
P.O. Box 402
West Byfleet
KT14 7ZF, UK
Phone: 0044-1932-403 509
Fax: 0044-1932-403 514

teNeues Iberica S.L.
Pso. Juan de la Encina 2–48,
Urb. Club de Campo
28700 S. S. R. R. Madrid, Spain
Phone: 0034-91-65 95 876
Fax: 0034-91-65 95 876

www.teneues.com
ISBN–10: 3-8238-4573-X
ISBN–13: 978-3-8238 4573-7

Bibliographic information published by Die Deutsche Bibliothek
Die Deutsche Bibliothek lists this publication in the Deutsche Nationalbibliografie;
detailed bibliographic data is available in the Internet at http://dnb.ddb.de

Editorial Project: fusion-publishing GmbH Stuttgart . Los Angeles

www.fusion-publishing.com

Edited and texts by Christian van Uffelen
Concept by Martin Nicholas Kunz
Editorial coordination: Sabina Marreiros
Layout & Pre-press: Thomas Hausberg
Imaging: Florian Höch
Maps: go4media. – Verlagsbüro, Stuttgart

Translations: Ade-Team, Stuttgart
English: Robert Kaplan
French: Ludovic Allain
Spanish: Margarita Celdràn-Kuhl
 Gloria Fochs-Casas

Printed in Italy

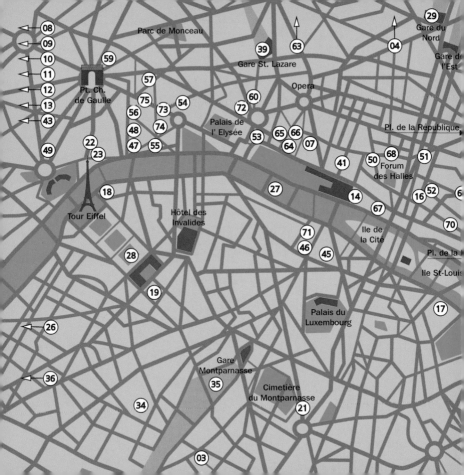

and : guide

Size: 12.5 x 12.5 cm / 5 x 5 in. (CD-sized format)
192 pp., Flexicover
c. 200 color photographs and plans
Text in English, German, French, Spanish

Other titles in the
same series:

Amsterdam
ISBN: 3-8238-4583-7
Barcelona
ISBN: 3-8238-4574-8
Berlin
ISBN: 3-8238-4548-9
Chicago
ISBN: 3-8327-9025-X
Copenhagen
ISBN: 3-8327-9077-2
Hamburg
ISBN: 3-8327-9078-0
London
ISBN: 3-8238-4572-1
Los Angeles
ISBN: 3-8238-4584-5

Munich
ISBN: 3-8327-9024-1
New York
ISBN: 3-8238-4547-0
Prague
ISBN: 3-8327-9079-9
San Francisco
ISBN: 3-8327-9080-2
Shanghai
ISBN: 3-8327-9023-3
Tokyo
ISBN: 3-8238-4569-1
Vienna
ISBN: 3-8327-9026-8

To be published in the
same series:

Dubai
Dublin
Hong Kong
Madrid
Miami

Moscow
Singapore
Stockholm
Sydney
Zurich

teNeues

01 Îlot Candie Saint-Bernard	14
02 Maison de Retraite	16
03 Logements sociaux, rue des Suisses	18
04 Résidence Universitaire Croisset	20
05 Tour Totem	22
06 Rue Pelleport	24
07 Place du Marché-Saint-Honoré	26
08 Cœur Défense	28
09 Exaltis Tower	30
10 La Grande Arche	32
11 Tour EDF	34
12 Tour Pacific et Pont Japon	36
13 Tour t1	38
14 Le Grand Louvre	40
15 Pavillon de l'Arsenal	44
16 Centre Georges-Pompidou	46
17 Institut du Monde Arabe	50
18 Musée du Quai Branly	52
19 UNESCO	54
20 Bibliothèque nationale de France Site François Mitterrand	56
21 Fondation Cartier pour l'Art Contemporain	58
22 Musée national des Arts asiatiques-Guimet	60
23 Palais de Tokyo	62
24 Cité de la Musique	64
25 Cité des Sciences et de l'Industrie	66
26 Fondation d'art contemporain François Pinault	68
27 Passerelle Solférino	70
28 Mur pour la Paix	72
29 Gare du Nord	74
30 Notre-Dame-d'Espérance	76
31 Parc de Bercy	78
32 Passerelle Bercy-Tolbiac	80
33 Promenade plantée Jardin Hector Malot et Jardin de Reuilly	82
34 Notre-Dame du l'Arche d'Alliance	04
35 Le Jardin Atlantique	86
36 Parc André-Citroën	88
37 Parc de la Villette	90
38 Saint-Luc	92
39 Lentille Météor St. Lazare	94
40 Métro Bibliothèque nationale de France	96
41 Kiosque de Noctambules	97
42 Aéroport Charles de Gaulle Roissy-2	98
43 Notre-Dame-de-la-Pentecôte	100
44 Cathédrale de la Résurrection	102
45 Artus Hôtel	106
46 Bel-Ami	110
47 La Trémoille	112
48 Pershing Hall	114
49 Hôtel Costes K	116
50 Étienne Marcel	120
51 Andy Wahloo	122
52 Georges	124
53 Joe's Café à Joseph	128
54 La Cantine du Faubourg	130
55 La Maison Blanche	132
56 La Suite	134
57 Lô Sushi	136
58 Les Grandes Marches	138
59 Café Nescafé	140
60 Shiseido la Beauté	142
61 UGC Cine Cité	144
62 MK2 Bibliothèque	146
63 Stade de France	148
64 Colette	152
65 Comme des Garçons Parfums	154
66 Giorgio Armani	156
67 Immeuble Pont-Neuf Kenzo	158
68 Mandarina Duck	160
69 Librairie Florence Loewy	162
70 Pleats Please Issey Miyake	164
71 Boutique Momi	166
72 Comme des Garçons Red-Boutique	168
73 Espace d'exposition Citroën	170
74 Fendi	172
75 L'Atelier Renault	174
76 Centre Commercial Bercy Village	176
77 Le Viaduc des Arts	178
78 Sephora Bercy	180